little america

Created by

Joshuah Bearman

Edited by

Jennifer Swann

Photographs directed by

Emily Berkey

little america

INCREDIBLE TRUE STORIES OF IMMIGRANTS IN AMERICA

Introduction by Kumail Nanjiani

MCD FARRAR, STRAUS AND GIROUX NEW YORK

MCD

Farrar, Straus and Giroux

120 Broadway, New York 10271

Library of Congress Control Number: 2019957725

ISBN: 978-0-374-18850-4

Designed by Unusual Co.

Our books may be purchased in bulk for promotional, educational, or business use. Please contact your local bookseller or the Macmillan Corporate and Premium Sales Department at 1-800-221-7945, extension 5442, or by email at MacmillanSpecialMarkets@macmillan.com.

www.mcdbooks.com • www.fsgbooks.com

Follow us on Twitter, Facebook, and Instagram at @mcdbooks

10 9 8 7 6 5 4 3 2 1

All interviews have been edited and condensed for clarity.

For everyone who came here from somewhere else

story map

contents

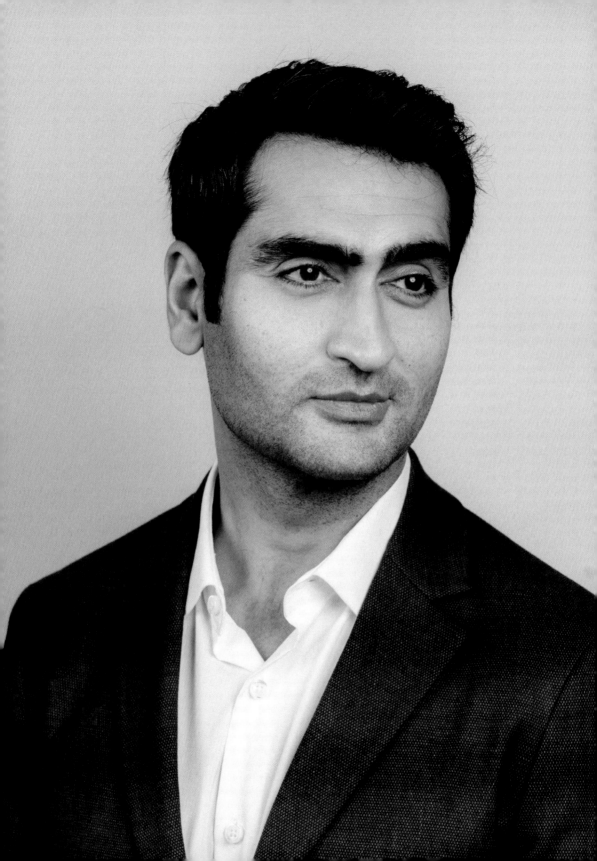

introduction

I was nineteen when I moved from Karachi, Pakistan, to Grinnell, Iowa, to attend a small liberal arts college. Karachi is a bustling port city of nearly 15 million people. It's crowded, rambunctious, teeming with energy. Grinnell, on the other hand, is vast, empty, teeming with corn. It was a true culture shock. Unsurprisingly, there weren't many South Asians in Grinnell, so people wanted to know who I was and where I came from. Not all the questions they asked me were smart ("Do you guys eat breakfast?"), but they were always asked with genuine curiosity.

By the time I graduated in 2001, I was ready to move back to somewhere more metropolitan, so I made my way to Chicago. Grinnell was wonderful, but I was excited to have dining options besides Taco John's and the meatball marinara six-inch at Subway. I landed a job with a tech training company that agreed to sponsor my work visa. They sent me a massive thousand-page manual and said, "We'll pay you to learn this entire manual and call you the night before we need you to start actually working."

I would stare at the manual out of the corner of my eye while I played video games all day with my roommate. Then at night, I would go up at various comedy open mics around Chicago, performing jokes I'd written for an average of thirteen people at a time. Initially, it was great: I was getting paid to play video games and perform stand-up comedy. How long could this last? The answer: two months. The day they called and fired me, I threw the manual in the trash. Then I realized that if I didn't find a job that sponsored my work visa, I would be deported.

In the midst of my frantic job hunt came September 11. Overnight, the political tide turned against Muslims. People who looked like me began to be treated with a sense of suspicion and otherness that I had never experienced before. I remember when I walked into a 7-Eleven in the suburbs of Chicago after tanking yet another job interview, one customer loudly said, "Hope you don't have your pilot's license." I even got harassed at comedy clubs. "Where's Osama?" was yelled at me so often when I was onstage that I wrote a response to that specific heckle. ("I have no idea. He hasn't called me in months.")

One night, about five years later, I was performing stand-up in the back of a diner when I was heckled again. Only this time, the heckle wasn't racist and it came from the mouth of a beautiful woman named Emily. Eighteen months later, we were married. By then, I'd found a job at the University of Chicago that sponsored my work visa. But our marriage, through which I got my green card, helped solve an important part of my immigrant story: the quest to remain.

Little America is based on the premise that every immigrant has a story. And at a time when political rhetoric so often demonizes immigrants, the stories we're telling on television and in the book you hold in your hands have the potential to shift that narrative. Because when you hear someone else's story, you're able to see your struggles in their struggles, your passions in their passions, your humanity in theirs. The narrator of the story ceases to be "the other" and simply becomes a person. Oh, and as for Pakistanis, yes, we do eat breakfast. Try the *halwa puri*. It's especially good.

—Kumail Nanjiani, Los Angeles, 2019

Photograph by Andrew White

Igwe Udeh

———

I remember the first time I saw a cowboy. It was a surprise—because I didn't think cowboys existed anymore. I'd only seen them in movies. It was the fall of 1980 in Norman, Oklahoma. I was sitting in a classroom at the University of Oklahoma, where I was getting my master's degree in economics. A slim, tall man strolled in. His heels clicked as he walked. He wore a red-checkered shirt, thick denim jeans, brown leather boots, and a wide-brimmed hat that obscured his face. He took off his hat and set it down. The hat took up its own seat, and nobody dared to sit there. I stared at him, in awe of his confidence. In Nigeria there were nomads who raised cattle and wandered from place to place, but they had no style. This man was the first American cowboy I'd seen in real life, and I was amazed.

I'm from a small town in Nigeria called Abiriba. I'm a member of the Igbo tribe. Growing up, I watched all the American Westerns—the John Wayne movies, Clint Eastwood movies. I know all the lines from *A Fistful of Dollars* and *The Good, the Bad and the Ugly*—both of which I must have watched fifty times. There were peddlers who'd come to our village, show American movies on a projector, and sell us American products. So I'd always had a vision of the cowboy in the back of my head. Cowboys were a myth, a symbol to us, but when I came to America my professors were cowboys, my classmates were cowboys. Oklahoma was full of them.

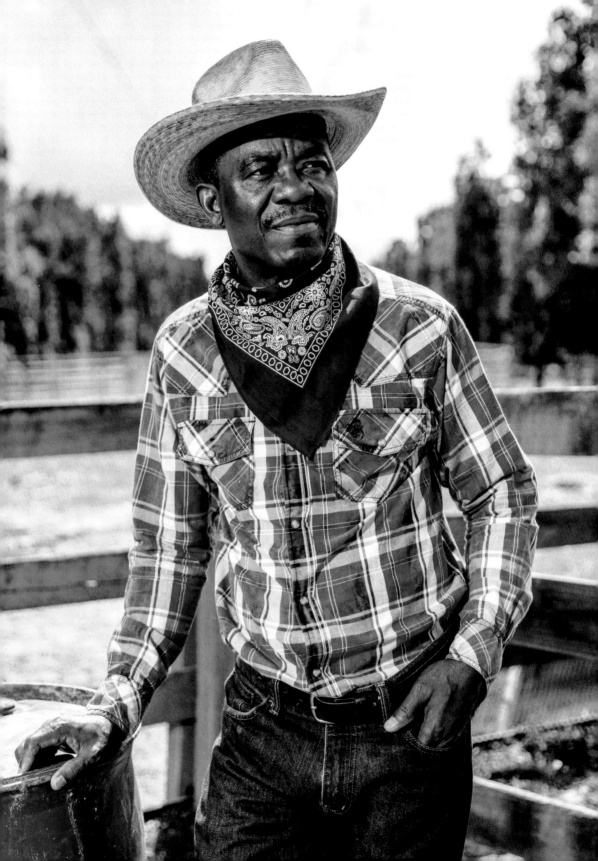

When I left Nigeria, the country had just emerged from a very brutal civil war. The country was devastated, so if you could afford it, you left for better opportunities. I was the only black man in my university program, and one of the few in town. I quickly learned that there was no barber in Norman who could cut black hair. I let my Afro grow. My accent was thick; to Oklahomans, unintelligible. Sometimes they'd pretend like they couldn't understand what I was saying. Some were rude, and I thought their attitude was . . . *unpolished*—let me put it that way. I'd go to churches where I was the only black person, and sometimes I'd be wearing traditional Nigerian garb like a *dashiki* or *isiagu* and no one would talk to me. They'd look at me like, "Why are you dressed like that?" I'd sit down and people would get up one by one from the pews and move somewhere else. I'd leave feeling rejected and alienated. I didn't become an American on the spot. I wanted people to know that I'm still African. They were proud of their culture, and I was proud of mine, too.

But I could also see the Igbo spirit in cowboy culture. The Igbo spirit is tenacious, and we are deeply connected to our land, which is rich and full of oil. I could see how much cowboys loved their land—they'd stay here forever, they would never leave it. Cowboys are unapologetic, too. Blunt. They do not care what other people think. I could imagine them a hundred years ago, when Oklahoma was still known for its quarries. They had to tough it out themselves. They could not depend on the government, they could not depend on anyone else. Coming from Nigeria, where the government was never on my side, I could identify with that.

It was easy to dress like a cowboy because that's what all the thrift stores sold—so eventually, I began to dress like one. I bought flannels and checkered shirts with silver glass buttons, secondhand jeans, brown leather boots that went up to my calf and made me taller. I couldn't afford the custom-stitched ones that other cowboys had. I tied a red bandanna around my neck because it reminded me of the white neckerchief my dad wore back in Nigeria. I even bought a Kawasaki motorcycle—the biggest one I could afford, even though I already had a car. It was my iron horse, and I rode it without a helmet because my Afro was too big. Everything about being a cowboy appealed to me, except chewing tobacco. I tried, but it always felt too disgusting. Back then, the floor of the university bathroom was covered in tobacco spit, and it made me cringe.

At first, people were confused about my new clothes. They'd never seen a foreigner with so thick an accent dressed up this way. They were tickled. The first time I walked into a classroom in my new cowboy getup, someone said, "Look at that! Igwe wants to be a cowboy." I smiled and replied, "Yes, I do."

I used to think about returning home and buying land in Nigeria—I thought that was where my kids were going to grow up. But that has changed. If I'm ever rich enough, I'd like to own a cattle ranch here. Maybe I'll go West, where there are a lot of trees and no swamp. I was invited to a classmate's cattle ranch once, and I was in awe. We played horseshoes and went skeet shooting. At the end of the day we ate very nice steak together. There was a lot of it. You could eat meat until it dropped out of your nose.

Interview by Natalie So | Photographs by William Widmer

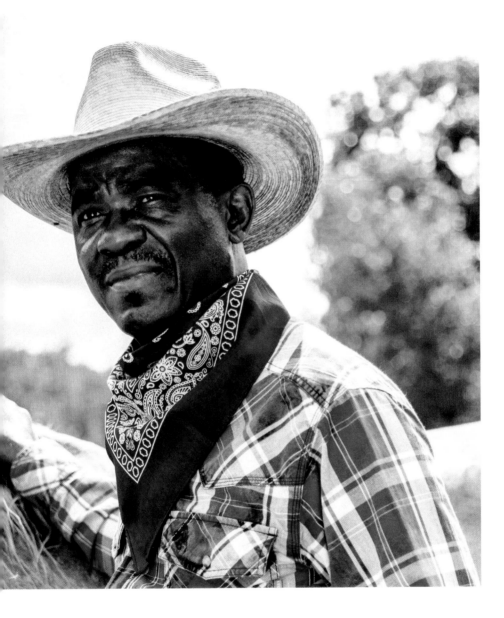

Jeannie Rice

———

I started running when I was thirty-five. It was 1983. I'd gone back to visit my family in Korea, and everywhere I went, it was a feast: kimchi, pot stickers, *bulgogi*, *japchae* with carrots, spinach, peppers, and mushrooms. They made so much food, and to be polite, I ate every meal. By the time I got home to Cleveland, I'd gained about, I don't know, seven pounds. And I'm short, only 5′2″—so I wanted to lose those seven pounds right away. That's why I started jogging.

Then I got hooked. I was always competitive, and when I first started running, we had a local race here in Cleveland—five miles. I knew the mother of one of my kids' friends was a runner, and she talked me into running this five-mile race, even though I'd only been jogging for a couple months. We're the same age, and she came in third in our age group. I came in fourth. I thought, If I train, maybe I can beat her. And that's the last time she ever beat me.

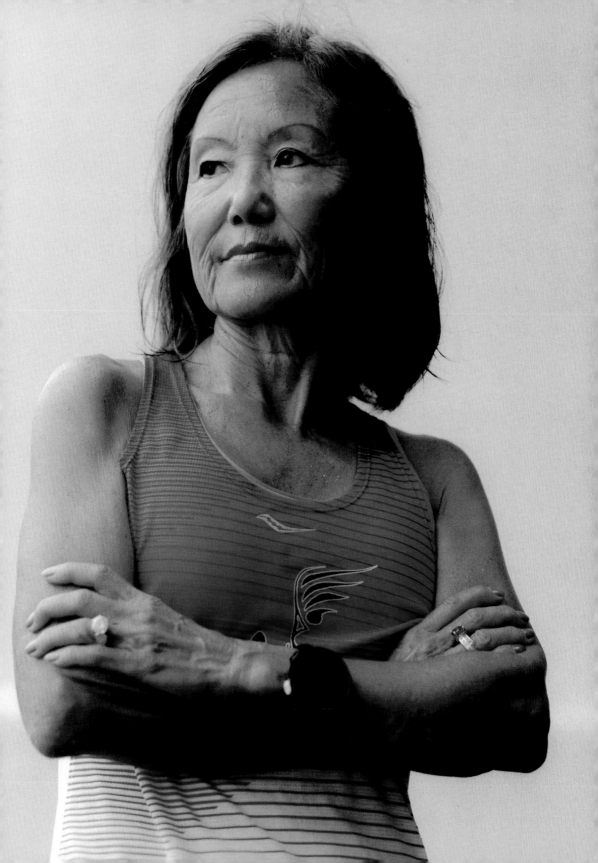

Less than a year later, I ran my first marathon. That's when I realized, Oh, I can run. It's kind of a disease. I've run 118 marathons in total. I went to New Zealand to run a marathon in 2000—the first marathon of the millennium! I ran the Great Wall in China. And finally, last year, I set the world record for women over the age of seventy at the Chicago Marathon.

I just turned seventy-one, and there aren't too many things women can do competitively at an older age. But running is accessible—there are races everywhere, just about every weekend, at just about every distance. I travel a lot for marathons. I like to pick different races around the world. And some people, not a lot, started to recognize me after Chicago—which is kind of fun. In November, I went to the New York City Marathon and was walking around Central Park just to see where our finishing line was, and a few people came up to me and asked, "Are you Jeannie Rice? From Ohio? Can we take a picture?" I even have a fan club in Thailand!

Ninety-nine percent of the people I ran with thirty years ago, they don't run anymore. If they do, they do short-distance. But I run fifty miles a week. I train year-round. In the winter, when it's too cold to run in Cleveland, I go down to my condo in Florida and I train with the Gulf Coast Runners club. The rest of the year, I run with a local group called the Northeast Running Club. It's all girls and boys in their thirties and forties—around my age when I first joined. There's a couple girls in their fifties. They look up to me. The other day, I went to TJ Maxx to kill some time, and I ran into this woman I run with, who's in her forties, and she said, "Oh my gosh, Jeannie. You're my inspiration. I want to be like you when I grow up." I said to her, "Well, you've got a long way to go, kiddo!"

It's funny—I often forget my age, because I compete with so many young people. My friend is a coach at a local high school and I go a couple times a week to run with his boys' cross country team. He thinks it's good inspiration for them because I'm old enough to be their grandma. These kids are fast, but I keep up with them—and I know none of them could beat me in a marathon or half marathon.

Girls didn't get to do a whole lot of sports in Korea when I was growing up. I did Korean dance. I did a little bit of ballet. But that was it. I came over to this country because my sister was already living here and she wanted me to study nursing. I studied business instead. After I graduated, I had a little café, and I also had a dry cleaning business. And then I became a Realtor. I've been in Ohio fifty years. I met my ex-husband and got married here. I had two boys. I have grandkids now. I've lived here longer than Korea. So, Cleveland is my home country now.

My granddaughters, Alyssa and Bailey—they both run, too. My friends say they've got my genes. Bailey just started running a month ago, so I took her to the store to buy some new running shoes. My son called me after that and said, "Boy, you should see her!" She's already run five and a half miles without stopping.

People always ask me, "Don't you get bored when you run?" But I don't. I think about things. I think about my family, about my next trip, about my next race. I dedicate miles to people I love—I feel that, spiritually, they know what I'm doing. When my sister was sick a few years ago, I'd always say, "I'm running for her today." I'd think about her in the hospital and in pain, and how I was so glad that I was able to run for her. When I run, I never get bored. I never think, Oh my gosh, I want to quit. I don't care how tired I am: If I say I'm going to run ten miles, or twenty miles, I'm going to do it. And all of this—that's a runner's high to me.

The day of the Chicago Marathon, I was just focused on not getting hurt. Knock on wood, I've never been injured from running. I felt good. The weather happened to be decent. The whole time, I was thinking about my grandkids—how they would be so proud of me if I broke the world record. By the time I was halfway through, I knew I had it in the bank, but I wasn't sure by how much. Then, when I crossed the finish line, I found out I had beaten the record by almost ten minutes!

Before the marathon, I'd written down the previous world-record time, 3:35, on a Post-it and stuck it on my refrigerator, and I looked at it every day when I went out the door. I like to have a goal. If you don't, I mean—why go out and work so hard? My older granddaughter, Alyssa, has a goal: She wants to run a half marathon in all fifty states. So I told her I would help her. After her high school graduation last June, I took her to Anchorage, Alaska, just she and I, just grandma and granddaughter. And I ran the full marathon while she ran the half. That was her first-ever half marathon. The weather was really good. The course was a little bit hilly, but very beautiful. I actually saw a bear—a baby bear! I finished my race—I beat all the men, by the way, in my age group—then I went back out to meet her and we ran the rest of her race together.

She's got the bug. In the spring, her mom took her to Napa Valley, and they ran a half marathon there, too. And my granddaughter came in third for her age group. She was so excited. She ran a Cleveland half marathon this year. And now that Bailey is running, too . . . Wouldn't it be amazing if the three of us ran a half marathon together sometime?

♥

Interview by Gina Mei | Photographs by Ricardo Nagaoka

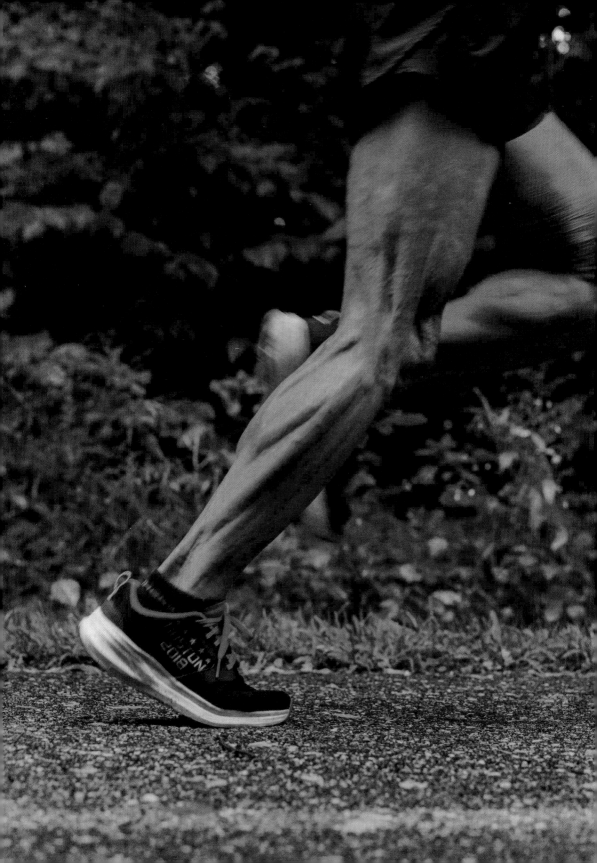

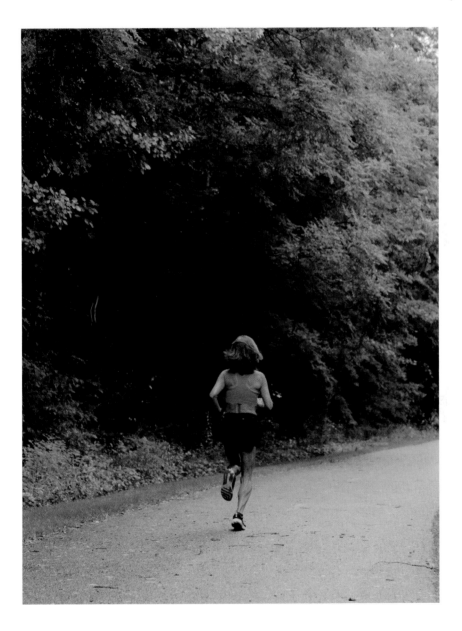

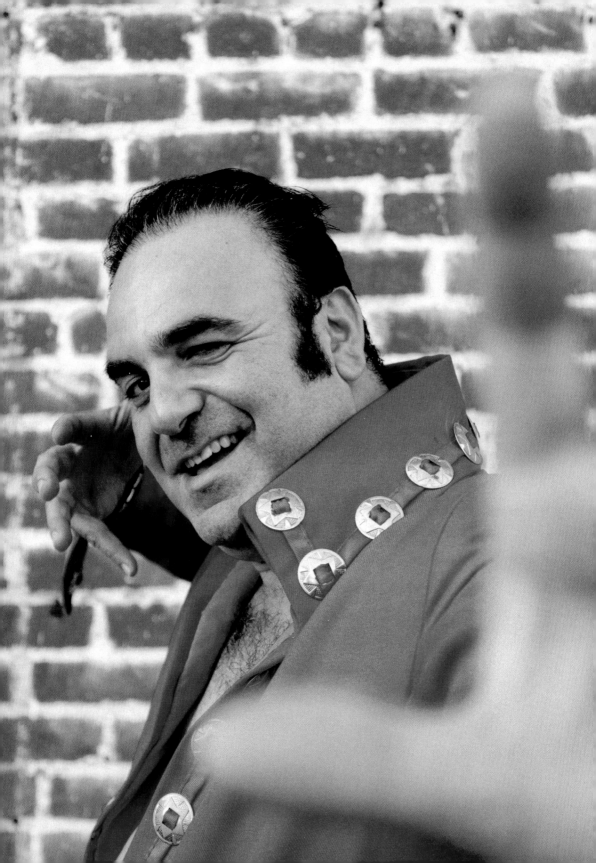

James King

———

I discovered Elvis when I was nine. I was in my living room in Beirut in the late 1980s, just watching TV, and they had the comeback special on. You know, the one where Elvis was wearing the black leather outfit? I started asking my sister, "Who's that guy? Who is he?" And she told me, "Ghassan, that's the king of rock 'n' roll." And then I sat down with my knees criss-crossed and my hands on the floor, just glued to the TV.

Pretty soon after that, my dad got me a bootleg cassette of all the greatest Elvis songs. I destroyed that tape, I listened to it so much. By the time I was eleven years old, I had every Elvis song ever recorded and I had memorized every single one. I couldn't explain it to my friends. For me, it was just the way he looks, the way he sings, the way he moves. He's a rebel but he's got the love in his eyes.

When I was seventeen, I put a rock band together, and we played all kinds of songs. Not just Elvis. We played The Beatles, The Doors, Roy Orbison, The Beach Boys. We played mainly at the Hard Rock Cafe. We were there every Wednesday. I kept this from my parents because they wanted me to finish school and get a regular job, which is very understandable. They wanted me to focus on my studies at university in hotel management.

But music was everything to me, and I think my parents could see that when I sang or played, it took me to another place. And so they never said stop playing music and I never stopped. It was my dream, you know? Then one day in 2000, my keyboard guy told me about a singing competition in Burbank. He'd seen a TV commercial for it. I didn't know what Burbank was. He said, "It's like Hollywood. Would you like to go?" I said, "My God, I would love to go. What do we have to lose?"

When I got to the competition in Burbank, I sang "Can't Help Falling in Love." I didn't win, but while I was there, I went to an Elvis Presley tribute concert and that turned out to be even better. During intermission, I went to the bathroom and started singing, "You Gave Me a Mountain." All of a sudden, another person started singing with me from a separate stall. When we came out from the bathroom, I looked at him and he was dressed up as Elvis! With sideburns and everything. I had never met any Elvis impersonators in Lebanon. There was no such thing.

I signed with that guy's agent and she told me to change my name because she said after 9/11 it was dangerous to have an Arabic name. I chose James because that was the name of Elvis's guitar player, and King because Elvis was the king.

My agent introduced me to other Elvis impersonators and we all became good friends. We would help each other out with the clothes, the jumpsuit, the rings. They showed me how to powder my chin to cover up stubble, and which adhesive to use so that my sideburns would stay on if I got sweaty. I would go to their homes and we would have dinner and play music and sing by the pool. I was so happy because I had made friends. We all had something in common.

What I learned from the other Elvises was that it's hard to make money just by doing Elvis.

Everybody had another day job. One Elvis worked with trucks. Another Elvis worked at Home Depot. And another mowed lawns and cleaned our agent's pool. The dream was always to make money from only doing Elvis. And one of the only ways to do that was to get a regular gig at a big venue, like the *Queen Mary*. That was the dream, working the *Queen Mary*.

Queen Mary is historical. *Queen Mary* is huge. Clark Gable was on that ship. Marilyn Monroe was on that ship. Charlie Chaplin was on that ship. It's a hotel now, where people from around the world come to relax, have a drink, and hear music. When you go inside, you go back in time. There's a burgundy carpet and a stage and *Mona Lisa*–like paintings. People come from all over the world to see the *Queen Mary*.

In 2002, I auditioned in front of the manager and people in the lounge. The ocean looked beautiful. When I was done singing, the manager said, "You're good. We want to keep you." I couldn't believe it. There's so many Elvis impersonators out there, you know what I mean? To get a gig at the *Queen Mary*? Come on.

I was so happy that I called my mom from a pay phone after the audition. My mom said, "Oh my God, I can't believe it, son. I'm so happy for you. Where is the *Queen Mary* sailing?" I told her no, it doesn't move anymore. But she was so happy for me. Later on I discovered this three-minute phone call cost eighty-seven dollars, but it was worth it.

Those years on the *Queen Mary* were the best of my life. I performed every Friday and Saturday. And sometimes they would give me Thursdays or Sundays. I was singing my heart out. I was in my early twenties, at the peak of young energy. I met people from all over the States. I met beautiful girls. I got so many gigs, too. Weddings, engagement parties. It was so good for me. I sang with joy. With passion.

Some nights I would have people who just wanted to sit down and watch me sing. And other nights, well, they just wanted to dance. And you see them all on the dance floor, going crazy. I had nights like those, where the people were dancing and sometimes it was so crowded they would dance into the hallway of the *Queen Mary*. And on those nights my manager would come to me and give me the thumbs-up. And then after the show, he would tell me, "James, James, James. If you only knew what you have done tonight."

But one afternoon, in 2009, I got a phone call from the management. They told me, "James, we're sorry to tell you that the *Queen Mary* has been sold and we're changing all the entertainment." They didn't want the Elvis act anymore. They wanted the new generation. So they put in an electronic music DJ and the twentysomethings started coming in, playing their own music.

I was in shock, but I tried to do my final performance the same as any other. To sing as best I could and look on the bright side: I'd have my weekends back. At the end of the night, I told the crowd goodbye. But of course they didn't realize the goodbye was not just "See you next time."

The weight of the loss didn't really hit me until months later, when the gigs slowed down. I had private gigs here and there. I did some competitions. But I never had a full-time gig like the *Queen Mary* again. The thing is, if you love Elvis and want to be an Elvis impersonator, you can do it in America. But you aren't going to make a record and sell lots of copies, you know? Eventually, I realized, Okay, I've got to really think about doing something else.

I am a truck driver now. I have a trucking company, and I drive my own truck. I drive those big eighteen-wheelers. I've been doing that for nine years. I go to Oregon. I go to Texas, Florida. I go to forty-eight states. I do long-haul. I like it. While I'm driving, I listen to music, I talk to my mom, you know? And I sing Elvis.

I still do gigs. Because, really, that's all impersonators can do. I can do gigs and competitions and support myself doing other jobs on the side. But that's all I can do. Because even if I win a competition, it doesn't mean anything. Because, in the end, I am impersonating somebody else. And he's already made it.

Interview by Emma Starer Gross | Photographs by Enkrypt Los Angeles

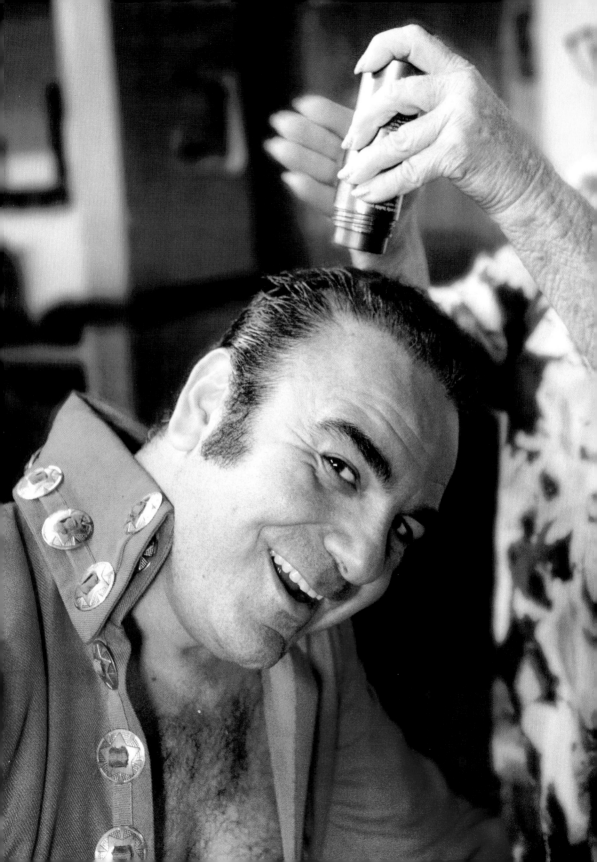

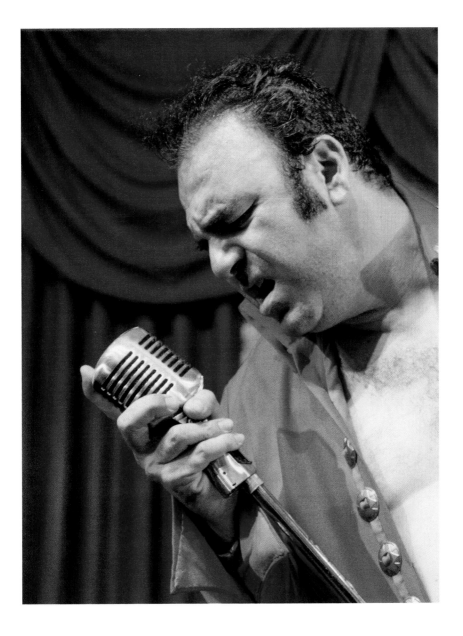

Yasmin Elhady

———

My dad was the Minister of Public Works in Libya under Muammar Gaddafi, but he had no idea what he was getting himself into. He was just an engineer who wanted to build bridges and roads. So when the regime started publicly executing people in soccer stadiums in the '70s, my dad was like, "I gotta exit stage left." He fled to Egypt, which is where he met my mom and had my brother and me. Gaddafi sent hit men to try to assassinate him for being a traitor, but luckily, they never found him. In 1989, when I was four years old, my mom woke my brother and I up in the middle of the night and said we were going on vacation. We ended up escaping to Jordan and then to Saudi Arabia and then the U.K., before finally reaching the United States.

When we touched down in Lexington, Kentucky, which was like a way station for Libyan refugees, we went straight to a church. I remember there was this beautiful nun who put socks on my feet and told me, "You're safe now." It was just a moment of utter humility. I thought, I want to be like this woman.

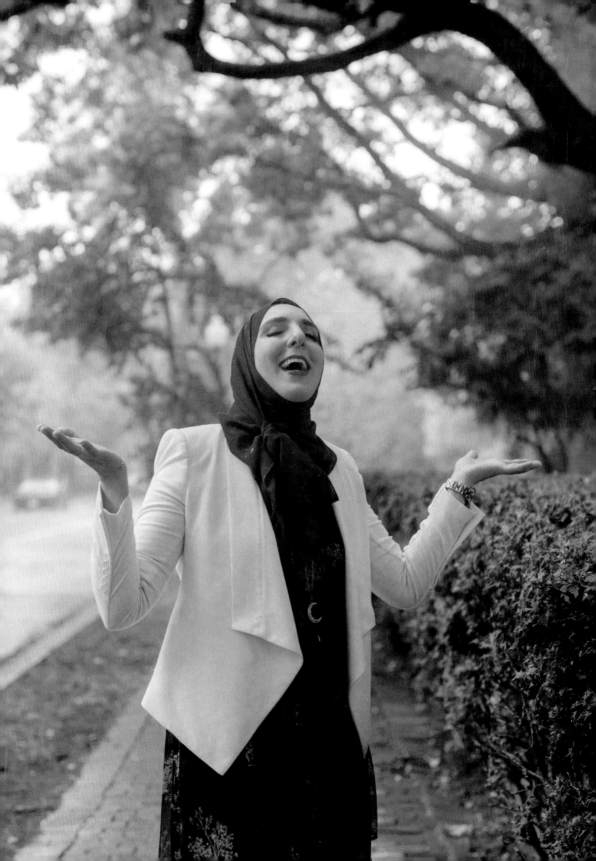

I decided to start wearing the hijab a few years before I hit puberty, which in Islam is the trigger for culpability before God. My parents thought I was nuts. My mom said, "You're squandering your youth! Go live your life!" But I thought it was really beautiful. It reminded me of the habit I'd seen on the nun.

A few years later, my dad heard about a Libyan guy who'd found work in Alabama. So, on a whim, we moved to Huntsville-freaking-Alabama in 1997, when I was in middle school. That other Libyan guy didn't even stay—he moved to New York a few months later! My father opened a small grocery— and by small, I mean it was a closet inside our local mosque—and later, a restaurant called Steak Express. My mother landed a gig as a secretary.

In Lexington, I had felt so confident wearing my hijab because I was surrounded by other refugees. But that confidence totally deflated when I arrived in Alabama. People would see my hijab and yell English at me slowly as if I wasn't fluent. All the kids at school pronounced my name "Yasma." This really popular guy called me "towel head," and my brother was constantly bullied because his name is Hussein. We felt very alone.

I was a junior at Grissom High School when September 11 happened. Everyone around me had the Christian Broadcasting Network blaring in their homes, saying, "Islam is not a real religion. They're here to attack us and take over our country. You can't trust a Muslim." I was booed out of a Walmart. I was refused service at the Ruby Tuesday. I had beer cans thrown at me out of the back of a pickup truck. I was threatened with a gun and thrown on the ground at the mall.

I think what was hardest of all was seeing my parents feel so scared and guilty that they had brought a visibly Muslim child to this pressure cooker called the South. My dad said, "Look, we had a good run with the hijab. But God is merciful. He won't mind if you take it off."

It crushed me to see my father have all this fear and anxiety about what could happen to me. I didn't want him to crumble like that. So I just said, "Look, if I'm not going to speak for myself, then who will speak for Muslim women? I have to stay true to who I am."

And suddenly my dad's whole face lit up with pride and he said, "This is how I know you are my daughter! You will run for president!" I said, "Dad, I can't run for president. I was born in Cairo." He paused and then was like, "You will run for president . . . of your class!" So I agreed to give it a shot.

Hussein was like, "Dude, you're so stupid. What did you promise Baba?" He was freaking out because our school elections were notoriously brutal—not to mention I was the only girl in a school of 3,300 who wore a hijab, running for class president two months after 9/11.

Then my brother got very serious and he said, "Okay, I got it. You're gonna rap your campaign speech. You're gonna diss the other guy. It's gonna be epic." I said, "Like a one-way rap battle?" He said, "Like a one-way rap battle."

Hussein and I wrote the lyrics over four days. I happened to be going to the doctor a lot because I had scoliosis, so I would practice my rap in the doctor's office waiting room, which raised some eyebrows.

I didn't stop there. I put up campaign posters around school that said, "Elect the Rising Muslim Star Yasmin Elhady" with a glitter crescent moon and star. Other variations of the poster read: "Scarf it down, Yasmin for Senior Class President," "Can't Scarf This," and "Scarf Girl to the Rescue."

I even got the cheerleaders to support me. One day, the whole team wore hijabs with little pieces of paper safety-pinned with the same slogans. That was huge. They were like, the elite.

I tried to make a mixtape to back me up, but I kept screwing it up. So the night before the election, I called this stoner I had been tutoring in math and asked if he could help. He was like, "I wouldn't be graduating this year if it weren't for you—I got you!" And he did not disappoint.

The next day, he handed me a CD he'd burned with songs off Napster. It had Vanilla Ice, Dr. Dre, and Snoop Dogg. It had Weezer. Kylie Minogue. Ludacris. Obviously, this was Alabama, so of course we had to do Lynyrd Skynyrd's "Sweet Home Alabama."

Now, my opponent, Tyler Green, was very popular and very mean. He was 6′3″, played all the sports and just crushed them. He killed the ACT and eventually got a scholarship to Duke. And he'd rub it in people's faces, too, saying things like, "If you think school is hard, it's probably because you're an idiot." I was like, How am I gonna beat this guy?

The day of the election, I was wearing a knit hat over my hijab with a piece of paper attached that said, "Yo Yo Yo MC Yasmin" and a chain made of aluminum foil. I was sweating bullets because I felt like if I lost, I would let down my father. I didn't want my parents to feel like they'd made a mistake by coming to Alabama—even if it was a difficult place to grow up.

So I got on stage in this huge auditorium and put on the Vanilla Ice song and I started rapping: "Yasmin, Yasmin Baby. I want you to stop, collaborate and listen. Grissom's back with a brand-new election. This school got ahold of me tight. Ask me any questions. I won't bite. White is the color . . . of my scarf. Green is the color . . . when you barf."

Then I pointed to Tyler Green. He looked like he was gonna cry. He gave a terrible speech and then said, "I don't know why you should vote for me anymore." It was both awesome and sad.

The principal announced the election results over the loudspeaker in home room, and I had won in a landslide.

That night, I couldn't stop beaming as I told my dad the news. He picked me up and spun me around and said, "That's my daughter! I knew it! All praise and blessings be to God who gave me her. She is my prize. I don't need sons, I want ten daughters like this." Hussein was like, "Okay, okay, slow your roll!"

As class president, I started a multicultural club to help people talk more about their differences. We did nursing home visits to show older people that we were all beautiful Alabamians even though we weren't all white. But my crowning achievement was breaking the school record by raising $1,500 to throw the best prom we've ever had.

I chose the theme Arabian Nights. Which I guess is sort of cheesy, but I leaned into it. I took all my friends to prom and Hussein brought us roses. I wore a long Indian dress, with a ton of bronzer. I probably looked like a Sunkist. Everyone wore bright colors, raw silk, and hand-beading. We were in Huntsville, Alabama, but it looked like we were at a sultan's palace.

Interview by Julia Black | Photographs by Kayla Reefer

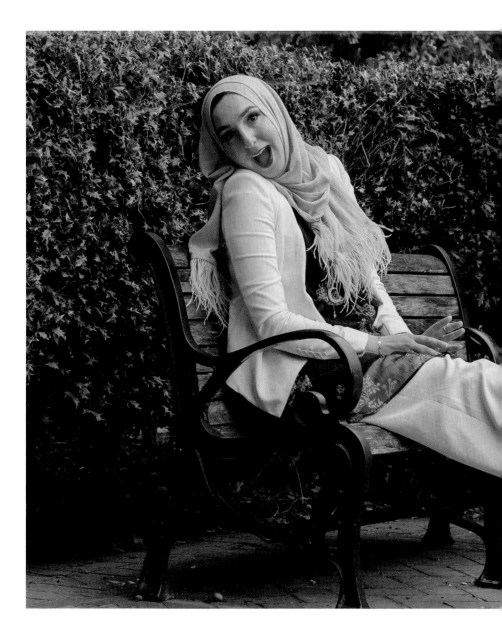

Reyna Pacheco

———

The first time I played, I was thirteen and undocumented. There were thirty of us packed onto a court. My school rented squash courts at a private club in Mira Mesa, San Diego, and divided them up with a big makeshift wall. On one side tutors helped with homework; against the other, we hit balls and watched them bounce high and hang in the air. I'd felt like I was barely surviving school that year—I'd been fighting other kids and had my mind set on leaving. I couldn't understand the point of college. My brother had dropped out of high school, my mom spent hours cleaning others' homes. But here was one thing I could focus on, swing at.

I wasn't great that first time. To be honest, I was the last kid to hold a racquet properly. But something about it appealed to me. I started bringing a racquet home—using it to pick up T-shirts and oranges. It became like an extension of my hand and made me feel kind of powerful. My brother kept asking me why I practiced this thing from the rich part of town and all I could say was, "It's different."

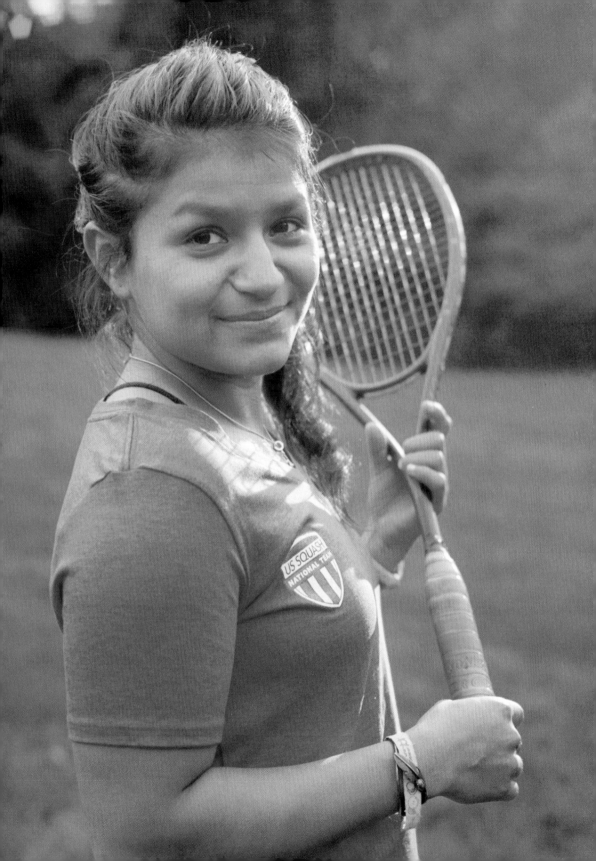

And it's true. Squash isn't accessible like soccer. There's no pick-up in neighborhood parks. It's played in a white cube. I could only go to the courts when paying members weren't using them. A lot of kids in America play squash to get into college. Their parents belong to private clubs, invest in lessons, and dream of the Ivy League. My mom didn't even feel comfortable watching me play. She'd say, "Reyna, look, my shirt isn't even clean enough for me to walk in there."

The courts I had to use were eighteen miles from my home; a thirty-minute drive if you have a car. My mom and stepdad needed their car for work, or sometimes didn't have enough money for gasoline. So I would take a three-hour bus ride at 4:00 a.m., hit balls from 7:00 to 8:00, take another bus to school, go back to the courts at around 5:00 p.m., and then head home. Sometimes if I ran late I'd have to race the bus from one stop to the next, or pound on doors until they opened, or even sprint into the middle of the street and demand the driver let me in.

I was surprised at how quickly I improved. I learned to volley on the side walls and came away from matches with scraped knees from battle. I couldn't take private lessons, but my coach, Renato Paiva, was a former Brazilian squash champion whose practices were academic quizzes and endless runs. With him I was always thinking, I must do more, more and more. This is why he made me team captain, even after I lost my very, very first match. That day I dove, I fell, and Renato said, "You have fighting spirit." And so I started planning my comeback.

Outside of practice, this game was a foreign world. Most tournaments are at East Coast boarding schools. I'd take five-hour plane rides with my racquet and sleep on the hotel room couches of my competitors. They'd be in their own made-up beds, and if they were nice enough to let me, I would sleep on the floor near the coffee table. And when we went to warm up, they'd be dressed in beautiful polyester shirts with red and white stripes. These are the jerseys you get when representing the U.S. in squash internationally. People I played with had tons of them—they'd hang out of bags and sit neatly in lockers. But I couldn't wear them, even when I was winning enough titles to become top fifteen. I was still undocumented. And that meant that I couldn't play in sanctioned events. I couldn't even travel the world. I could tell that these parents buying $300 hotel rooms and kids with laundered jerseys weren't able to understand what brought me to the court, why I stayed.

It wasn't because this sport was different. It didn't feel that way to me anymore. During tournaments, I'd hit the ball, and it'd always come back. This return always had something unexpected—spin, bounce, the direction of my opponent's feet. I had to be aware, constantly pushing and perfecting and ready for my next shot. This immediacy fit how I was living—at school where I didn't know if I'd be in the country for our next exam, and at home where we turned boxes into chairs and wondered when the next check would come in. I had to take it all day by day. Squash had a rhythm that matched my life.

There was a game that my friend's father, Dickon Pownall-Gray, played with his wife: They would sit at bars, look at people, and guess: "That woman in velvet is a fashion editor," "The person reading *O Globo* is a translator." One day, they saw a guy sitting surrounded by books, looking studious. "An academic." "A Wall Street man." They had to ask. He turned out to be an immigration lawyer at one of New York City's biggest law firms. Mr. Pownall-Gray wanted me to have the same opportunities as his own daughter; he told this lawyer about my case. I don't know what he said. What I know is that the lawyer took me on pro bono and I agreed to trust him, though I was nervous. My family had tried to apply once before and a lawyer told us, "Don't try again, you're going to get kicked out of this country." But with this lawyer, I filled out a lengthy application, got fingerprinted, and went in for my interview. Just as all my classmates were beginning to apply to college, I got an envelope. A totally standard one; USPS Priority. My green card had arrived, but it still felt like an impossibility.

Now, I'm able to travel the world. I'm asked questions about the election, about walls, about growing up in a place that had crime and drugs. And it's odd because I'm the American—but I'm also Mexican. Residency doesn't mean I'm not thinking about my identity. It doesn't make me feel like I definitely belong. I'm always adjusting to new places and people, and that's part of life and training and squash. Things are never guaranteed. All I know is that on the court I feel safe to push boundaries, to set goals. On July 8, 2016, I played in my first U.S. Federation event. I wore a shirt with a red, white, and blue logo. Before putting it on, I held it in my hands and cried.

\

Interview by Alexa Daugherty | Photographs by Mark Hartman

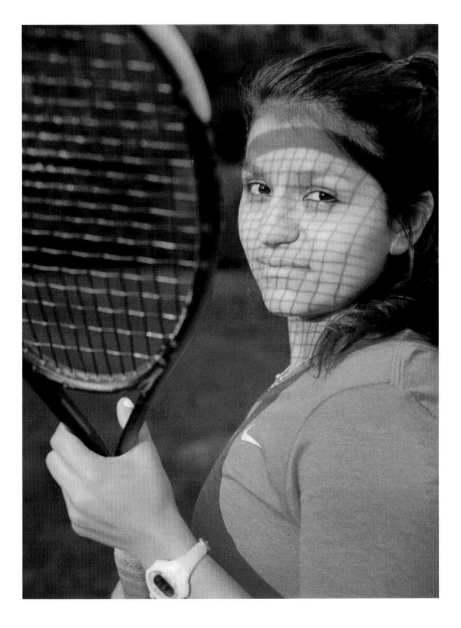

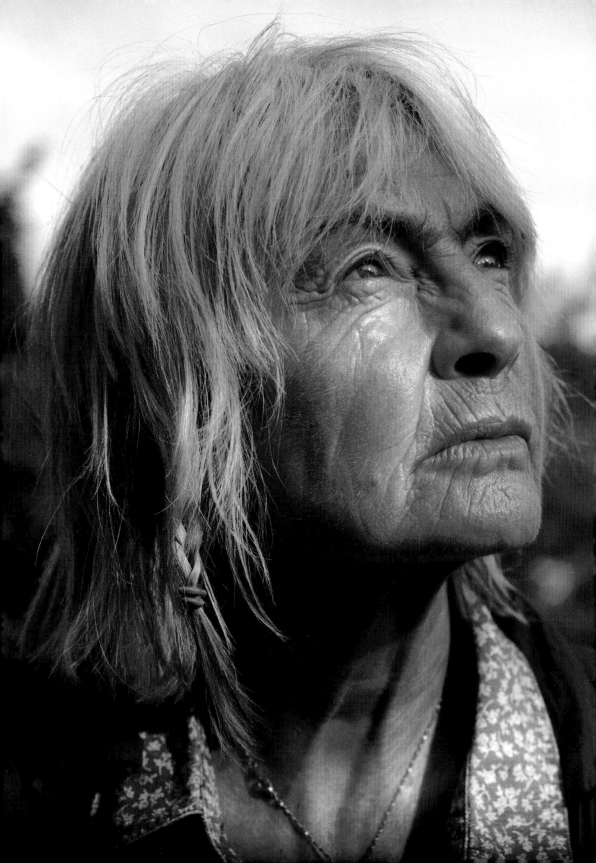

Yemana Sanders

———

My parents, they loved adventure. They would travel. But when I told them I was leaving my hometown of Bern to study meditation in India, they said, "Great, now our daughter is in a cult." It was 1980 and I protested, "Humans have climbed every mountain, seen every river, but we haven't looked within. How will we move forward?" I spent two years in India, and then I learned of a yearlong silent retreat in Massachusetts. I thought: Why not?

I had been at the center in Massachusetts for nine months when Clark arrived. A lot of people came for one or two weeks. They came and went. Clark was new, arriving toward the end of my time there. He came because his little cabin had burned down. At the time he was having women left and right—he was very good-looking—and a friend told him, "Maybe it would be good to break the pattern." As his cabin was burning down, he thought it would be a good time for some reflection. He was there for a five-day retreat, and had never done anything like it before.

Everything was silent. When you sit and say nothing for a long time, you spot things, and your mind makes up incessant little stories. It creates and reacts. You wonder, you doubt. You see people who pique your interest, and you have an internal romance with them. You marry them, divorce them, create a vendetta against them—whatever you make up in your mind. "Oh, this one looks awful, I would not want to talk to this person." Or: "There's a nice person. I want to know them." We were supposed to watch out for the romances where your mind says, "Aha—I am in love with this person," even though you have not spoken.

Clark spotted me right away. At that age, I seemed to catch men's eyes. He wasn't like the other men there, whose energies skewed feminine. He reminded me of Thor Heyerdahl, a figure from my childhood. That was my idea of adventure: strong, sunburned, and with an earring. I had never had the experience of a real male energy.

One afternoon, a teacher led us through awareness exercises. She had us stand in a circle, look at each other, and then put our hands on another person's head. We weren't supposed to look up much. But I remember I had on these little red Chinese slippers. Clark was across from me. He put his hand on my head and energy shot through my body.

At the end of his five days, he wrote me a note: "I'm leaving town now. Could we go for a walk?" It was a short walk, and it was then that I heard him speak for the first time. We didn't communicate well. He was still transitioning out of his silence—but he also didn't really talk much, even when not on a silent retreat. Before he left, Clark gave me a second note. He asked if I wanted to come visit him. I hesitated. I had spent a year in silence. I did not know what a true relationship was.

I arrived in upstate New York in May. It had been two months since we had last seen each other. Clark was building a house, and he lived in a tent under some trees with his dogs. He had a little seat and a gas lamp outside his tent, and he would read there. At night, you could see only the outline of a tent and a man reading. I said to myself, "Well, this gets as close to Thor Heyerdahl as I could imagine."

I stayed with Clark from May to July, in that tent under the tree. We still didn't speak much. But I was pregnant, I'd learn. Clark was the father.

My daughter was born, and two more children followed. We grew in unison. When the kids were small, he started telling them stories. They were captivated by his stories. He was animated, inventive. He was again like Thor Heyerdahl. But when the kids were grown, I needed to go off on my own again, to adventure again. Clark and I parted ways. He is remarried now, and I am alone. Happy as a clam alone.

Interview by Emma Starer Gross | Photographs by Kathryn Harrison

Mohanad Elshieky

———

On a summer night in 2012, I got in the car to drive to a friend's house and play some video games. I was twenty and living with my family in Benghazi, in the house my grandfather had owned for generations. The area had become really sketchy, and so most of our neighbors dealt drugs, and people from other parts of the city would come to my neighborhood specifically to purchase drugs.

I hadn't been in the car for probably more than a minute when I saw all these people blocking the street in front of me. I thought maybe there was a fight or something. There was a line of cars behind me and I couldn't back up, so I just figured I'd wait. I thought, What's the worst that could happen?

Then, out of nowhere, this lady appeared and her face was covered in blood and she was screaming for help. I wasn't sure what was happening or what was wrong with her, but whatever it was, I didn't want anything to do with it. I thought, I'm not going to intervene. I'm just going to continue driving once this clears up.

That's when this lady made eye contact with me, opened the back door of my car, and got in. Just jumped in the car! For a second I was like, Does she think I'm someone else? I was going to look back there and explain that she had the wrong guy, but then the passenger-side door opened and in jumped this bearded guy with dark curly hair. He pulled a knife out. Then he shouted, "Drive!"

The guy told me which neighborhood to drive to, and for the first two minutes, nobody said anything. My mind was racing. I was thinking, Should I call someone? Should I text my dad? But what was he going to do? He wouldn't have taken it seriously. He would've probably been like, Oh, well, make sure the car is safe. But I couldn't have called anyone even if I wanted to anyway: My whole body felt like it was frozen, like I could barely even move my feet to drive.

Then the dude looked at the woman and he was like, "Hey, don't worry. Me and this guy, we're going to make sure we get you home safe." Then he looked at me and he was like, "Isn't that true?" And I was like, "Yeah, man. Anything you say. You have a knife." But I still wasn't convinced that he was trying to help this woman. I thought, I bet this dude is the one who planned this whole thing.

Then the woman started crying and mumbling and I put the story together that she had been at her brother's house and apparently got into it with her sister-in-law. I think her sister-in-law just smacked her in the face. She was yelling about how much she hates her brother and how much she hates her sister-in-law and I was like, Okay, well, I do hate your sister-in-law more than you right now, just to be honest, because I'm the one stuck in this shit now.

A few more minutes went by, but they felt like hours. Then the guy just started chatting with me, like he wanted to get to know me. He asked me how my day was going and where I lived exactly, and what my last name was. Then he started asking me, "Do you know this person, do you know that person?" I realized he was trying to make sure that we didn't know any of the same people so that I wouldn't be able to identify him. The weird thing was, we had so many friends in common, because we went to the same middle school. After that I figured, Man, there is no fucking way this guy's going to let me live.

All I could think was, I literally live in a war zone and it would be so embarrassing if this was how I died. I had been working as an English-language interpreter for the journalists who came from abroad to cover the war in Libya, so I was used to driving people all over town and taking them to the front lines, and yet, that didn't even compare to my current situation. And I'm not the type of person to get frightened easily: My friend and I hosted a radio show that got us a lot of heat because people thought it was too liberal and very secular. We'd talk about politics, religion, whatever. We'd get death threats and think, Look at that, we're really killing it right now. Eventually, we had to stop the show because someone burned down the radio station.

We got to the woman's house and she and the knife dude got out of the car and met this guy, I think it was the lady's husband, and they started screaming at each other. I guess I could've just driven away, but I thought maybe some other car would try to block me in, like something out of an action movie. My other line of thinking was just, Okay, this guy knows who I am. If I leave him here and something happens to him, then he's going to find me. And some part of me really did want to know what the hell was going on. I mean, if I lived, I wouldn't be able to tell this story and end it with, "Then I just drove away."

That's when the lady's husband came back out of the house with an AK-47. And I was like, Holy shit. Is he going to kill the knife dude right now? Then he noticed me parked outside the house and ran toward me, pointing his gun. He was like, "Who the fuck are you?" So I just sat there and I was like, "Okay, dude, I'm not sure how to explain this. I don't know anyone here, I don't know what the fuck is happening right now, I hate everything." He was just yelling at me, asking who I was, over and over again. And I was like, Oh my God, is he going to shoot me?

In hindsight, I get why he was upset: His wife's face was covered in blood, and there were two strange men in a car that drove her home. He was probably like, What's up with that? The neighbors must've heard screaming because they came out of the house and were like, "Man, calm down. Don't shoot someone. You're going to regret this." Eventually he calmed down and went back inside the house, and then the knife dude walked over to me, opened the car door, and sat down again like we were best friends. He was like, "I was just trying to help. I could have just stayed on the street corner working. Everything was going well." And by working he meant selling drugs.

I stayed quiet and started driving him back to the neighborhood where we both lived. He started playing with my radio, and for some reason, he picked this AM channel that was playing opera music. And then, because the night kept getting worse and worse, we got stopped at a checkpoint. Normally, I know where the checkpoints are and I avoid them, but by that point I wasn't thinking. And I couldn't turn back because the guards would know that I saw them and then it could be worse for me.

There were two different kinds of checkpoints in Libya at the time: Ones run by the Libyan military and ones run by militias affiliated with al-Qaeda and ISIS. But both groups wear the same type of clothes, and I couldn't tell which group this was. When they began searching the car, obviously they found the knife because it was in the pocket of the passenger-side door. They were like, "What is this? What are you doing with it?"

And I didn't know what to say so I was like, "This is not my car. It's my dad's." I knew the car's registration was under my dad's name, so I just blamed it on him. I was like, "That's his knife, I don't know what he does with it." And then they started making jokes about it. They were like, "What do you think you're going to do with this? Literally everyone has guns these days, and you're here with a knife." And I was like, "I honestly have no idea what I'm doing. I just want to play video games. Just let me go."

But by then they just kept messing with me. They were like, "So what's your deal? Are you with us, or are you with them?" What they meant was: Are you pro–Libyan military or are you pro-militia? And I was like, Fuck, man. They weren't wearing badges and I had no idea what group they were with. There was a fifty-fifty chance of me getting it wrong, and I couldn't risk it. But apparently the drug dealer next to me had been through these checkpoints multiple times before, so he had the correct answer. He was like, "We support God." And then they were like, "That's great, that's all we need." Because to each of the groups, God supports them no matter what.

Once we finally got back to our neighborhood, the dude with the knife thanked me for the ride and said, "If you ever need anything, just let me know." And I was thinking, I just need you to stay out of my life. But two weeks after that night, I found out he was shot to death on my street. I think it was a drug-related thing, and I don't think they ever caught the guy who did it. There wasn't really law controlling the city then. You could just get away with it.

Of course, none of this mattered to my friend who I had planned to hang out with that night. We're still friends today. He teaches English in Turkey and I do comedy in Portland, Oregon. But I'll never forget the day after this car ride, when I told him about the woman with the bloody face and the guy with the AK-47 and the checkpoint, he was totally unfazed. I guess living in a war zone, you get numb to this stuff. He was like, "You could've just told me you didn't want to come over and play video games."

Interview by Jennifer Swann | Photographs by Ricardo Nagaoka

Roberto Behar

———

Rosario and I have known each other since we were twelve. But I was always afraid of asking her out because she's taller than me. Then, by chance, we both decided to study architecture and suddenly we were in the same university.

It was 1976 and there was a military dictatorship in Argentina. We were young, I had long hair and all of that, and you know, we were rebels. Militant. One of Rosario's sisters was killed, and one of her brothers was in jail for five years without a trial. It became clear we had to leave. Rosario had it in her head that we would go to Europe. But for me, the objective was always the States. My grandfather was a Sephardic Jew who immigrated from Turkey and he always used to say that he regretted taking the ship to Buenos Aires and not to New York. Somehow that became part of my psyche. I had to get to New York City.

When I got accepted to the Institute for Architecture and Urban Studies, I finally got my chance. My grandfather agreed to pay for my schooling, but no more than that and so the only apartment I could afford was on Avenue A and East Second Street in the East Village. It was an old tenement. The WC was in the hallway and the bathtub was in the kitchen. There were cats everywhere. And in the doorway of the apartment there was a sign that said, "If anybody's following you, do not open the door." It was different, let's put it that way. It was very, very different.

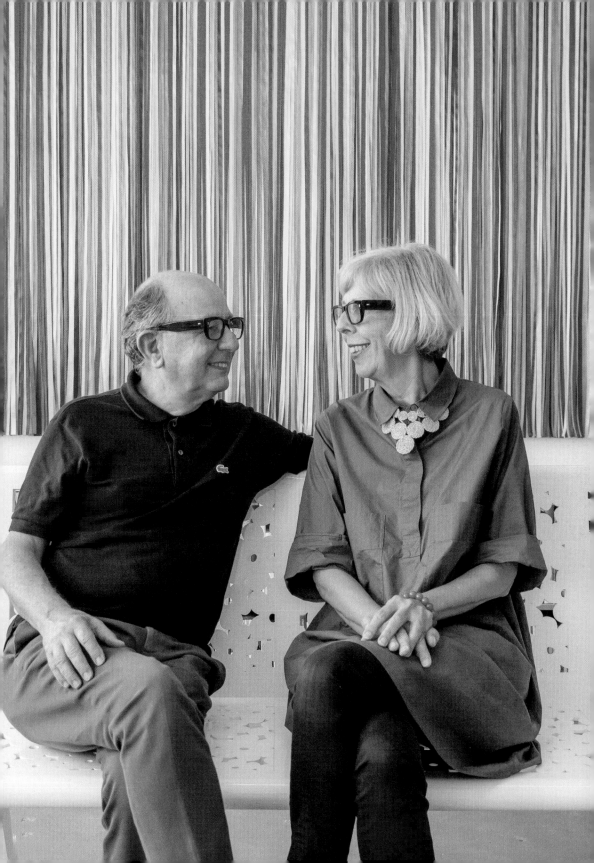

I kind of began to lie to Rosario about how great the apartment was so she'd move here with me. She sold our motorcycle and bought a plane ticket to visit me in New York a few months later, and at first it was kind of a strange world for her. The neighborhood was punk and Puerto Rican mainly, and there were heavy, heavy, heavy-duty drugs and prostitution. But the incredible thing is, when you're young, you can get used to things really fast and then it becomes normal.

When my classes finished up, my grandfather stopped sending money. I'd been applying to architecture jobs with no luck, and it became increasingly difficult to live in the city. Then one day, we learned about this job where you could drive a car across the country. Older people were coming from New York to Miami by plane, but they needed somebody to drive their cars down for them.

It made a lot of sense for us because we already had a place to stay in Miami, but couldn't afford to get there on our own. My uncle had just passed away and my cousin had to go clean out his house. He called me up and said, "Why don't you come over and join me for the summer?" I had been to Miami once before and I liked it a lot. So I told Rosario, "Miami looks great. We should go." She thought it was just the first stop on our way to France.

It was May of 1983 and I remember it vividly. We went to pick up the car in Times Square, in the Paramount Building, which is like this Mexican pyramid thirty stories high. We went inside of that building and we got this big '70s Cadillac, a very big one, with shiny rugs inside.

We set out on I-95. It was our first road trip, an initiation of sorts, and it was all very beautiful in a way. We stopped in a little supermarket in Charleston, probably to pick up some hot dogs, because we really had no money whatsoever, and everybody stopped what they were doing and looked at us.

In those days, Charleston was run-down, half-destroyed. And here we were, these two young people, coming out of this big Cadillac, and we had these accents that were very unique, very, very unique, and suddenly, we realized, Okay, we are not normal, we are different.

We got back in the car, and I remember when we drove through Savannah, it was so new to see people on the streets smiling at us. That was not something we had experienced back in Argentina, or even in New York. We felt a big sense of welcoming, and freedom was very pervasive, in a way. It was here, there, and more or less everywhere.

At one point I took a wrong turn, and all of a sudden we were alone on a road that was under construction. So it was brand-new, and yet empty. It was like a dream, in a way. We were listening to the radio, and as we got closer to Miami, we realized there were almost more stations in Spanish than there were in English. We got on the causeway and we began to see these pink islands in Biscayne Bay. The artist Christo had just covered them in this woven fabric, and I thought, What is that about? What is that pink that we see? You have to imagine, the sky was super blue, the water was blue. Thinking back, it was a pretty fantastic moment. Everything seemed to be truly possible.

Then we get to South Beach and it's this part of town that is beautiful, yet coming apart, completely dilapidated. There are all these Jewish people that once upon a time were young and were at the beach and are now very, very old sharing the street with these very, very young Cuban people who look like they're in *Scarface*. Miami at that point was a second-rate city in the minds of Argentinians. It was not part of our mental map at all. But we felt completely at home very quickly. Everyone was from somewhere else and we were all in search of this new place. The landscape, the weather, the beach. We felt it was the place we had been looking for, in a lot of ways, without even knowing it.

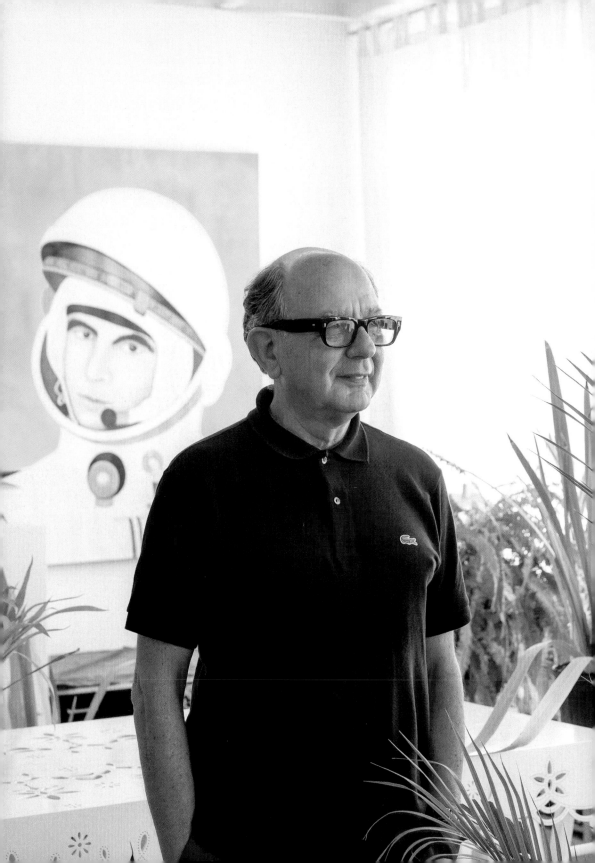

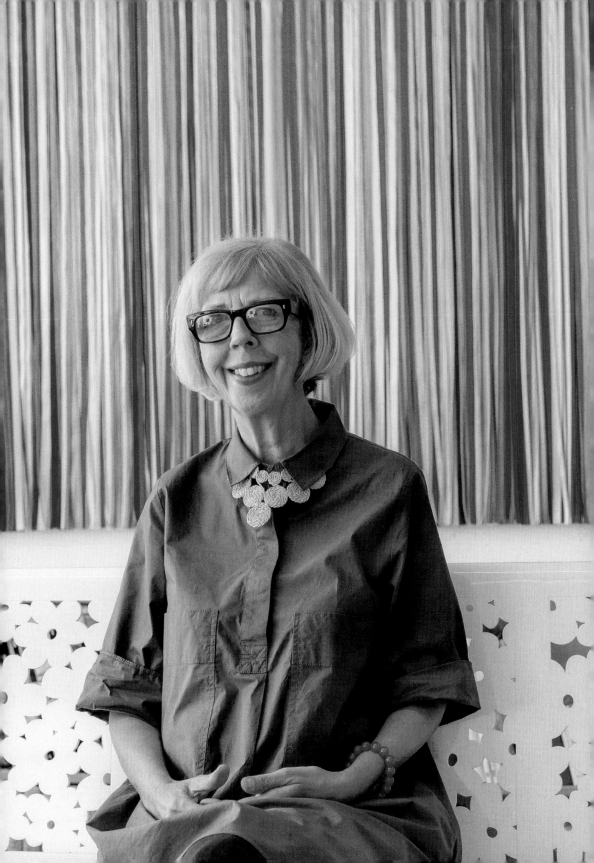

Rosario and I began to take on architecture projects as a team. We founded R + R Studios in 1995, and the next year the county commissioned us to create a forty-five-foot M at the entrance to the Miami Riverwalk. We always like to present it as the biggest M in the world, in part because we are interested in this question of the colossal in America—the biggest, the tallest, and all of that. At the Miami International Airport, we spelled out the words *peace* and *love* in these big plastic flowers on the wall. It's inspired by roadside billboards and it's the first thing international travelers see when they land.

But not all of our renderings have been realized. Some are utopian ideas, based on what we think the city should be. Like spelling out the words *I love you* on the Miami skyline or reshaping one of the islands in Biscayne Bay into a star. The bay is private, and we've always dreamed of creating a public park within it. For us, every project is part of a kind of cultural project in a way. And we always tend to think of Miami as a kind of laboratory. A kind of new America.

Our next plan is to make a museum with our little house in the Art Deco district. We want it to be a time capsule of the moment when people like us came into town, before the city turned one hundred years old. We think it's going to be our last contribution to the city.

Interview by Jennifer Swann | Photographs by Kayla Reefer

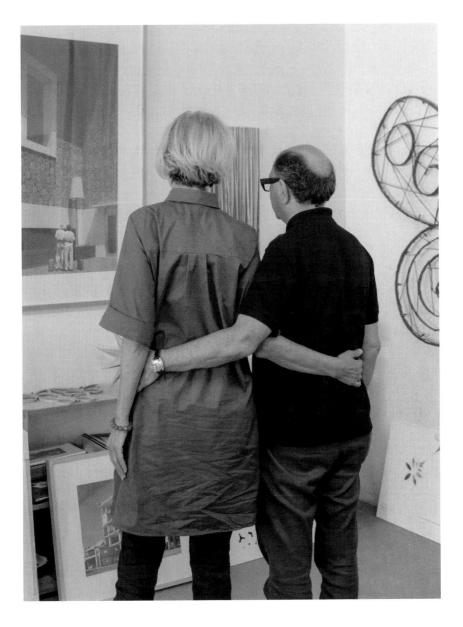

Farhad Gremipor

———

A few months ago, I was online looking at real estate sites and I found a really great piece of property for very cheap. It was a very good deal—maybe too good for Yonkers. It was $19,000. It should be $200,000! I thought I'd found a deal like no one else has found.

I went there to see and I found out there is this huge rock in the middle of the land. I mean, this thing is huge. It's like eight feet high and maybe fifty to sixty or seventy feet long. The rock takes up maybe thirty percent of all the land. Let me check my papers. Yes, the rock is exactly 7,535 square feet.

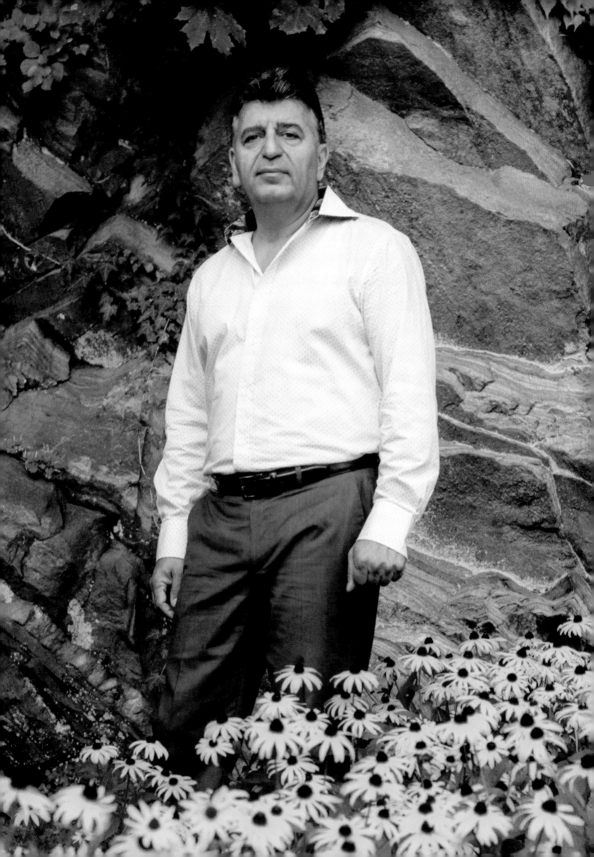

In Iran, we lived in the country, on a big farm filled with apples, grapes, almonds, and pistachios. Farmers brought cows and sheep and goats to my ranch and I'd auction them in the early morning at the bazaar. I still have my ranch there because one day I wish to go back. I dream of returning to Iran. I never wanted to live in the United States, but my wife and I left Iran in 2016 because my kids were coming to America for college. We thought they were too young to be here on their own. So we moved to Yonkers.

But now I must build a house. Now, my wife and I live in an apartment, but in our culture, back home in Iran, having a house is very important— there we live together most of the time. My kids will go to school nearby. It's different in America. This is why I need to have a house for my family. My parking lot business is in Yonkers and so I'm really just looking for land in Yonkers. I'm not the kind of guy who wants to drive two, three hours during rush hour. You want to know the distance from my business to my house in Iran? A five-minute walk.

So, okay, I say, No problem. It's a rock. I will destroy the rock. I figure, why not just hire someone to remove the rock? I do some research on companies that have the equipment and skill to move such a giant rock. I found a few and asked for price estimates. How much to remove this rock? They all guessed around $80,000 or $120,000. That was too much. So I went back to one of the companies and I used my skills as a businessman from working at the bazaars in Iran to negotiate. I'm not in a hurry, I said, I'm going to pay you guys in cash to remove the rock. Anytime your employees have nothing to do, come over to this land to start chipping away at the rock. They gave me a good number for that deal.

First we have to chip the rock and make room for the driveway and the two-car garage. It's going to be a four-bedroom house with a very big kitchen for my wife. She wants the very big bedroom and very big kitchen. Then we just have to nail the house to the rock. So the house will be on the rock. Actually, it's a nice foundation. We won't see the rock out the window at all. We will see a view of a beautiful green valley.

There will be some problems to start. The rock makes problems. Sewage and digging, for one thing. But I think I can handle it. You have to have perspective. You know, this is why I fly, this is why I paraglide. I have a paragliding site in my backyard in Iran. Paragliding is my habit. I can't stop. I started six years ago. I was driving to my ranch when I saw a man flying through the sky, and I stopped and asked a man on the ground, "What is this?" The man said, "It's not for you, it's for the young guys, and it's not good for your heart." I said, "I'm not that old!" He said, "Well, if you want to try flying, try it tandem with me." I said, "I want to try it right now." And so I flew. I did. And I loved it. It is my dream. I have to do it every weekend.

When I'm flying up there, everything looks very small. Every person, every city. The problems you have down below become very small. Difficult problems suddenly become easy. Down here, you think, This is going to take a lot of thinking and doing, but up high, it's nothing. It's a pack of cigarettes. A big rock becomes nothing. So if you can get up there, then you can live better down here.

We sometimes fly as high as 11,000 or 12,000 feet. Do you know how high that is?

Did I tell you? Next month I will fly sixty-five miles from Mont Blanc to Switzerland. And soon I will fly in Rio de Janeiro, and I will fly over the Jesus. This is my dream. I'm going to do it with my wife next year. One day I might buy another property in America on top of a huge hill and maybe I can fly from there. For now, every day I see the giant rock. I drive by it every day. It's right next to my apartment. In fact, I can see it through my window right now.

Interview by Jen Percy | Photographs by Kathryn Harrison

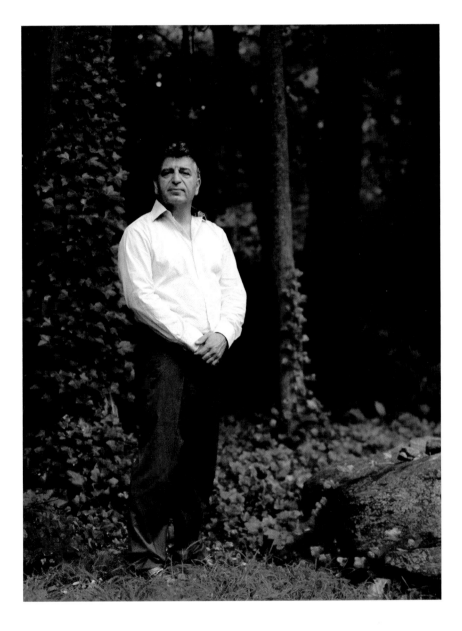

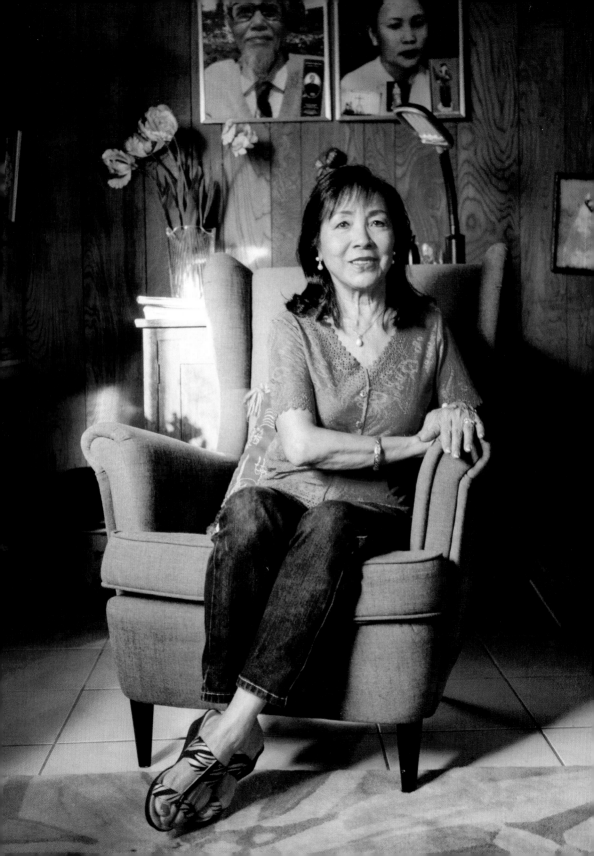

Thuan Le

———

The fall of 1975 was cold and wet. I was living with my family in Hope Village, an old hospital that had been converted into a refugee camp near Sacramento. The winds from the mountains were so chilly that I had to cut up donated blankets to make coats for my children. I hadn't thought to pack jackets when we escaped from Saigon with the Viet Cong closing in. But it didn't matter. It might have been cold, but Hope Village was a huge step up from the tent city in Guam where we first became refugees.

One weekend, Tippi Hedren flew in from Los Angeles. I knew she wasn't just a volunteer—she was a Hollywood actress who had a glamorous home and pet lions from Africa. When I got to the classroom, I noticed her immediately: Her pinned-back blond hair stood out among a sea of black. All my classmates were crowded around her, eager to tell her about their progress, which only made me more nervous.

Tippi saw me slip in and held out her hand to beckon me closer. As I walked over to where she was standing, her bright orange-red nail color caught my eye. I somehow got the courage to take Tippi's hand in mine and see it for myself. Her fingers were impeccable—long and slender with oval-shaped cuticles. But it was her nail color, simple and elegant, that stopped me cold. It was the most beautiful thing I had ever seen.

Tippi asked me how my vocational classes were going and I sheepishly confessed that I wasn't any good at typing or sewing, so I'd stopped going.

She paused for a moment, looked at me, and said, "I think I have something else for you. You can learn to do nails." Back in Saigon, that was not a serious job, let alone a skilled job that you needed a license to do. But in America, Tippi said, only the rich and famous could afford manicures and pedicures. It was considered a luxury. And I wasn't just going to be a regular manicurist, Tippi said, but "a specialist."

All the other women started to get excited about the prospect of working in beauty salons and meeting movie stars. And so, about a week later, nineteen other refugees and I enrolled in manicure classes with Dusty Coots Butera, Tippi's manicurist. Dusty started each lesson by working on someone's nails while we circled around to watch and take notes. She taught us what a nail buffer does, how to hold a filer, which direction to sweep the brush. Dusty knew a strong foundation would prepare us for the harder part to come: the Juliette wrap, which involved gluing paper on top of the nails to create firmness.

Eventually, Tippi went to a local beauty school and negotiated for us to take nails-only classes so that we could qualify for the state license test. Every day for the next two months, the camp's volunteers took us to school with our brown-bag lunches. As I got more comfortable with the nail equipment the guests we practiced on started tipping me—not much, just a dollar or fifty cents—but it made me so happy. I had finally found something I was good at.

A few months later, all my classmates and I passed the state test and Tippi threw us a party at Hope Village to celebrate. I wore my most valuable possession, the yellow silk *ao dai* I had brought with me when I escaped Saigon. When Tippi strolled in wearing an almost identical one— she bought it from refugees at a Hope Village fashion show she helped organize—I felt a rush of pride. By that point, my family and I had found a church to sponsor us and were getting ready to move into our own place.

As we raised our champagne glasses to celebrate, Tippi turned to me and said, "If you need anything, just call me."

Not long after that, we settled into a small two-bedroom apartment in Santa Monica. I looked for work at the few local beauty salons, but had no luck. Meanwhile, my husband slogged away as an exterminator. He'd come home with bumps on his forehead from banging his head on the ceiling of tiny crawl spaces. I should've been happy to be outside the camp, but instead, I was desperate and depressed. The day I called up Tippi in November 1975, I felt like she was my last hope. She picked up the phone, and without any hesitation, said she would love to help me.

She arrived at my apartment a few days later. I was mortified. My children were running around, scattering toys all over the living room. We didn't have much furniture—just an old couch and a four-piece dining set donated to us by a church—but Tippi didn't mind. We chatted briefly about what the other women from my class had been up to, and the next day, she took me job-hunting.

When we arrived at an upscale salon called Beau Jacques, I was overwhelmed by the gold-colored walls and the hair-drying station that rose above the floor like movie theater seating. I looked around in silence; I didn't know what to say. Then Tippi nudged me and I presented my state license and a recommendation letter that she had written for me to the owner. He peered at my license for a long time, then fixed his gaze on me. He said he already had four manicurists on staff and wasn't about to hire another one, but I think he took pity on me because he let me work standby Sunday through Tuesday. If there were too many customers or if another manicurist was slow to finish, I would fill in.

But it turned out getting the job was the easy part. The few clients I had usually just wanted a simple coat of paint, which cost only a fraction of a Juliette wrap. Most days, I was lucky if I took the bus home with ten dollars in my pocket. After a while, I found more steady work at two other salons. I thought about quitting Beau Jacques, but I didn't want to disappoint Tippi. Eventually, I got promoted to a permanent chair and I worked there until it closed in 1984. One of the hairstylists opened a new salon after that, and the whole crew from Beau Jacques moved over. I stayed there for decades.

In 1995, the staff and refugees from Hope Village organized a reunion at Tippi's home at a sanctuary she created for endangered lions. I packed up my car with a batch of homemade Vietnamese spring rolls and a gift: a handcrafted lacquer painting depicting a tiger stretching his paws. A friend had brought it back from Vietnam, and I thought it was perfect for Tippi. When I pulled into the parking lot of the preserve, I could see Tippi talking to the camp staff from afar. She turned around, waved at me, and walked over. I eagerly took out the gift from the back seat, only to find that the glass covering it had shattered on the bumpy car ride over. I was so embarrassed. I apologized profusely. But Tippi, with the same reassuring voice I had heard on the phone that November day twenty years ago, held my hand, offered a warm smile, and said, "Thuan, don't worry. We will fix it."

Interview and translation by Anh Nguyen | Photographs by Enkrypt Los Angeles

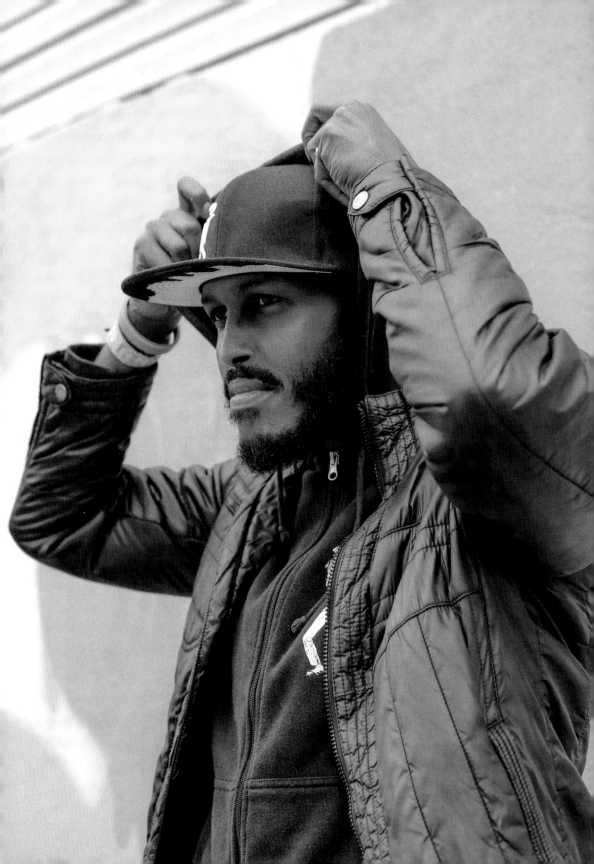

Jamal Hashi

——————

When I was twenty, I had a small restaurant in downtown Minneapolis. It was a mom-and-pop deal hidden on a little road called Eat Street. There was no menu so you would have to come in and know what you want to order. So it was just regulars, mainly Somalis. There were hardly any Americans. Ever. But as a Somali chef, I felt like it was my responsibility to change people's minds.

The only way to really get your food in front of mainstream Midwestern eaters is to get into the Minnesota State Fair. It's the place to go. You get to sell food to millions of people, you know? Who wouldn't want that opportunity? Once you're in the state fair, you become part of this community. The state fair represents Minnesota, and Somalis are a big part of that.

In the beginning I applied with *sambusa*. It's a traditional fried pastry stuffed with ground beef. Once you bite into it, it feels like a pillow. Then you get hit with the spices: cumin, onion, garlic, curries. Every Somali house has *sambusas* during Ramadan. It is a staple. No response. Then I applied with roasted goat cutlet wrapped in *chapati*, which is a flatbread that makes you say "Mmm" when you taste it. Somalis eat it twice or even three times a week. Still no response.

But camel? Camel is something Somalis have consumed, historically, for a very long time. It's in our poetry, it's in our history. Nomads, my ancestors, swore by the camel. Camel was for special occasions. It's called the food of the kings. If you have a bad day, you say, "Let's have camel." When you have camel, you're going Kardashian-style big.

For six months, I experimented with every recipe I could think of. The meat is really tough, so tenderizing it is difficult. Even in a kabob, it just came out really tough to chew, you know what I mean? So then I got the idea to grind it up and season it. I put bread crumbs in it to hold it together. And soon it just became like a tasty camel on a stick.

The story with the state fair is everything is on a stick. If you can get it on a stick it's an item. Fried Snickers on a stick. Deep-fried Twinkies on a stick. Pig ears on a stick. There was one Palestinian guy who was doing lamb testicles on a stick. It was wild! So when I came up with camel on a stick, I had such a good feeling. I thought, Yes, this will do it.

After I applied for the sixth time, the state fair organizers invited me to the office. They said, "If you can get us camel meat on a stick, okay. Give us samples." So I brought samples to them and they all loved it, particularly because they'd never heard of such a thing. They said, "Camel? Like, camel camel?" It took them aback. They said, "We're going to make you the featured item of the year. That means you're going to be on all the buses, you're going to be on all the ads. We're going to give you a tent in the International Bazaar, where people come to try food from all over the world. Are you ready for this kind of challenge?" I said, "This is all I've waited for all my life."

But getting in became the smallest hurdle, you know what I mean? First I had to figure out how to get camel imported in bulk to the United States. There was an importer who had given me a shipment of camel for my restaurant, but it was a small quantity and it was super expensive. Now I needed four tons of camel, and camel meat isn't even a market here.

I was able to work out a deal with a company that could get us a couple of pallets of camel all the way from Australia. It's hunted from a helicopter in Aboriginal lands, and it's slaughtered about five weeks out so it's really fresh. The meat was actually approved by the FDA.

Then, the day before the grand opening of the fair, we were up late preparing the meat in our kitchen and the sprinkler system went off. The water was almost ankle-deep, and no one knew where the valve was to shut the water off. It was three in the morning and I was running around scrambling. I fell and broke two of my ribs on the side of a steel table. I was in a panic because I'd already done all these radio and TV interviews and I was worried I'd have nothing to show for it.

So I brought my whole staff over to another kitchen and we dried up and got right back to work. Around 7:00 a.m., I sent some of my guys over to the fair to get the grills going. There was already a line of people wrapped around the block. We opened the doors at 9:00 a.m., and my God it was nerve-racking. We all looked at each other, my staff looked at me, and I said, "Do not worry, we're going to serve one person at a time. One person at a time."

It was just nonstop, nonstop, one person after the next. And through–out the whole event, I'm in pain because of my broken ribs. I can't go to the doctor because I have to be there fourteen hours a day. I have to show my face, I have to be in front of the media, the cameras, the people who are coming, you know? It's part of the whole deal. And I can't leave my staff because I'm supposed to be the captain of the ship.

The state fair goes on for about twelve days, but we sold out of camel in four. It was just incredible. No sleep. After that CNN came to do a big story around it, *CBS Evening News* and all these news outlets. People would recognize me, like, "Hey, the camel guy!" I'm like, "Hey, hey!" I am recognized as the camel guy here to this day.

Eventually I came up with the Hashi burger, which is a camel patty on a bun with a slice of pineapple and American cheese. It was like a must-have dish at my restaurant. It actually inspired me to open what I believe is the first Somali restaurant in New York City, in 2015. Now I have my own organization. I work with restaurants that are trying to get their concepts together.

I'm still riding this camel thing a bit. Right now I'm working on creating my own camel protein bar. Once people find out that it gets you lean, it doesn't get you fat at all, I think it'll catch on. It gives you more bang for the protein than anything else on the market.

I don't know if it's a genetic impulse because I come from a long line of nomads, but it has become a lifelong thing for me to constantly adapt so I never have to panic. When a certain area would have a drought in Somalia, my family would pick up their things and go somewhere else. They would constantly keep moving. To move and adapt, that's how we survive.

Interview by Jennifer Swann / Photographs by Katra Ziyad

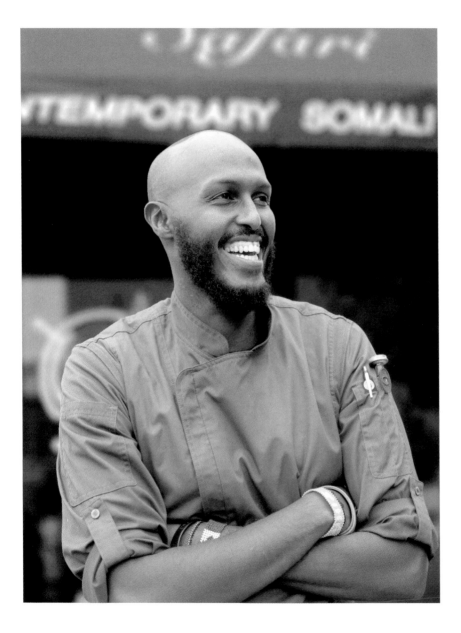

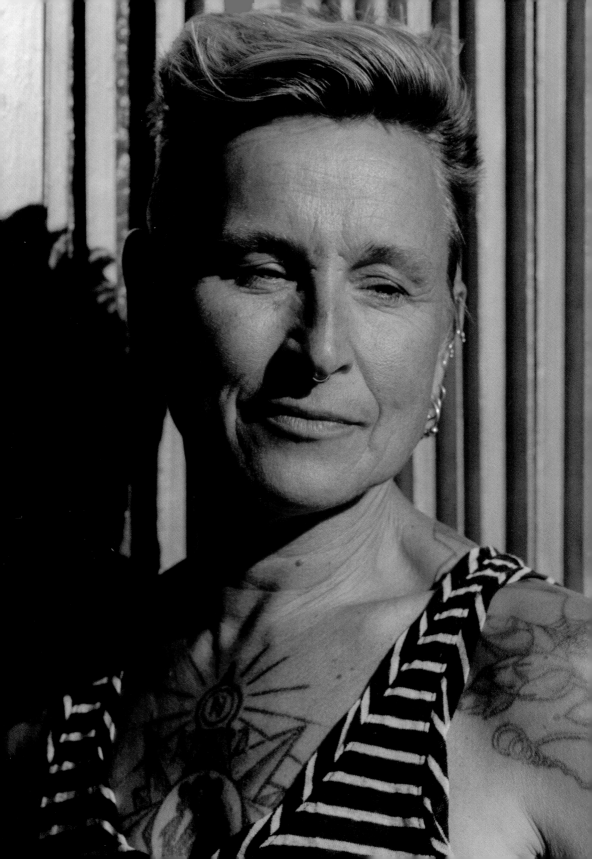

Idexa Stern

———

The first time I visited San Francisco, I was so naive. My friend took me to see a drag show at a club called Finocchio's and at first I didn't realize the performers were cross-dressing. When I figured it out, I was amazed. It was 1986 and I was nineteen. My gender had always been fluid, but in Bremen, Germany, where I grew up, I didn't have any kind of queer community. My short hair and facial piercings made me stand out, and in my hometown, standing out wasn't a good thing: One time, in my early twenties, I was harassed on a bus by an old woman who looked at me with disgust and told me I should be gassed.

The next time I visited, two years later, I was in college in Hamburg and I'd been reading a lot of Angela Davis, the influential feminist activist who lived in San Francisco. I just felt a pull, like I had to be in this city. I attended a women's march while I was there and I remember one woman from Jamaica sang her speech, and there was another woman translating it into sign language, dancing along. It felt so positive, especially coming from Germany, where the feminist demonstrations I'd attended always felt dreary and militant. It was at that rally that I realized I didn't just want to go on vacation to San Francisco. I wanted to start a new life there.

I moved to San Francisco in 1992, when I was twenty-five, and decided to get my first tattoo later that year. I drew the abstract blackwork design myself. I ended up stopping into a well-known tattoo shop, but I didn't realize you had to make an appointment. I got lucky because there was an artist who had a cancellation. He tattooed me on my pelvis for an hour and a half. It was really intense and very intimate to share this painful experience with a stranger, but we didn't talk at all about the intention behind the tattoo or the meaning it held, even though I was thinking about it the whole time. It was a transformational moment for me, but for him, it was just another day at work.

Historically, tattoos have been a way of signifying that you belong to a group. The markings tie you to other people, like members of a tribe or even sailors, bikers, and circus performers. Getting tattooed was a way to tether myself to my new community of queer people. I felt safe and accepted in San Francisco in a way I never had before. And because I was a stranger in America, I didn't know the rules and that gave me a lot of freedom to express myself. I wanted my first tattoo, a tribal design, to commemorate that.

Not long after I got tattooed, I was in the sauna of a bathhouse and a woman noticed the artwork on my pelvis. She told me she was married to Fakir Musafar, a body ritualist and shaman I had read about in a book on primitive tattooing, and she thought he would be interested in photo-graphing me for his magazine, *Body Play*. I wasn't sure if it would be com-fortable having an older man take pictures of me nearly naked, but when we met a few weeks later, we had an instant connection. He told me he had also felt very alone when he was in his twenties. That there was no community for him, so he made his own.

Several months later, he gave me a job working as an assistant for him and his wife, helping them run their magazine. And he introduced me to Black Leather Wings, an S-M group that performed intention-setting rit-uals, often to help members heal from traumas. One of the first rituals I participated in was a body suspension, in which I was pierced with twelve hooks and then hung from the ceiling of a warehouse. The pain was excruci-ating, but worth it—I entered a trance state. I felt a kind of spiritual ecstasy, maybe similar to what people experience in churches when they sing gospel, but with a more physical aspect.

Around the same time, I did a Hindu ritual called Kavadi, where you wear a frame of spears that work themselves into your body as you dance. That was probably the most meaningful ritual I've ever experienced. We were performing the ritual outside, and I felt like part of the sky opened up. I could see huge trees around me, living things so much older than any human being, and birds swooping through their branches. I felt like my energy was mingling with the energy of the environment. It really made me believe we are so much more than our bodies.

I wanted to do more to bring ritual into people's lives, so, eventually, I taught myself how to tattoo. Up until that point, I had been practicing piercing and branding and drawing designs for my friends to get tattooed by other artists, but it always felt like I was just a tiny wheel in the machine. I wanted to do the whole process. So, in 1996, I opened my own shop, Black and Blue Tattoo, with another female tattoo artist who became my business partner. There were very few women tattooing at the time and we wanted the shop to be more than just a place where the equipment was sterile and the energy was good—it needed to be a space where women felt comfortable.

To me, tattooing is the process of bringing out something that's already part of the body. The work is already there, and it's my job to draw it. I draw freehand directly onto the skin, and as I draw, I listen to people's stories and I translate them into an abstract image that works with the contours of their body. I try to pick up on my clients' energy and put it back into them. The drawing is not necessarily representational, but it often symbolizes a specific time in a person's life. I do a lot of line work, a lot of flowing shapes and repeated geometric patterns. I want each tattoo to be unique and individualized to the person getting it, so I don't draw symbols that have been used over and over—like the yin and yang—or flash tattoos picked off the wall.

A lot of times, my clients have gone through something difficult and they're trying to move on from it. Getting tattooed is about letting go, about opening your life up to new things. My clients and I have a little bit of a therapeutic relationship, and the tattoo is really only a part of the experience. It's the visible part, which is very important. But there's so many things that play into it: how well we connect, and how we collaborate, and how much they're involved in the process. My sessions are always better when I get more feedback from my clients. Even when there are some communication hurdles, those sessions have more meaning because of our collaboration. If I can help my clients become truer versions of themselves, then I've done my job.

Interview by Sasha Geffen / Photographs by Ricardo Nagaoka

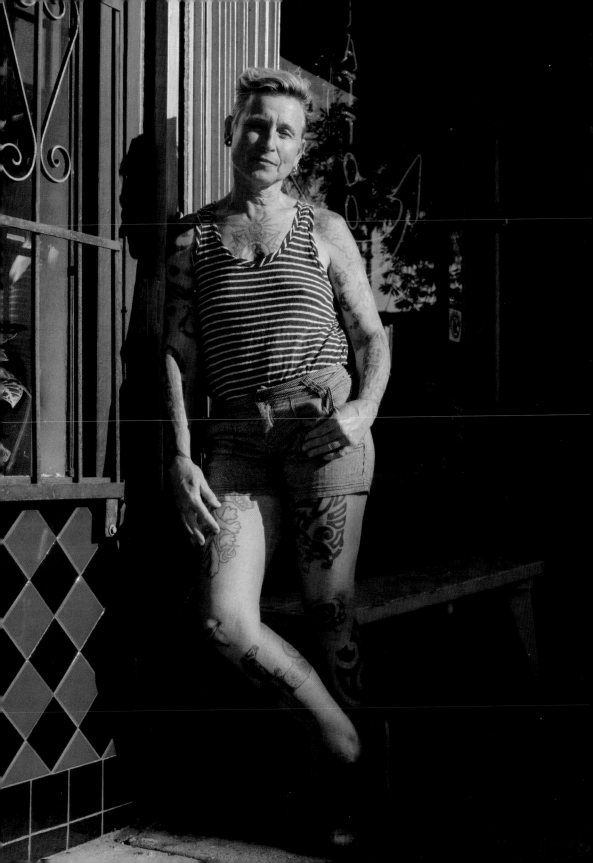

Mary Anne Mohanraj

———

When I was ten, I discovered a box full of zines underneath a table at a Star Trek convention. They weren't like anything I had ever encountered before: homoerotic stories about Kirk and Spock, two characters that I loved. I sat there for an hour hanging onto every word. It was my first encounter with sexually explicit material of any kind, and I was fascinated. Maybe even aroused, though I wouldn't have been able to identify it back then. I went home that night and never mentioned it to my parents.

I went off to college at the University of Chicago in 1989 and my hormones must have kicked in, because suddenly, I couldn't think straight. It was almost shocking to me how strong my sex drive was, how it made it hard to make good decisions or show up to class in the morning. My first boyfriend, Dean, and I fooled around so much that I ended up flunking calculus.

I had been raised to be a good Catholic girl in a conservative Sri Lankan family, and the stuff about pregnancy and STDs and all that really stuck in my head. So Dean and I took it slow, but it still got very, very heated. After we had sex, it was like another dimension of myself had opened up. I realized that my mom had warned me about all the wrong things, like how I'd shame the family if I got pregnant. But she didn't say anything about how sex is amazing and it's going to feel so incredibly good that all of your good sense is going to go out the window.

Dean dumped me after four months. Then, during my sophomore year, I met Paul. We fell in love and I didn't want to spend any time away from him, so I would hang out with him while he worked at the computer lab until three in the morning. He was enough of a techie that he knew about newsgroups at a time when most people were still just starting to get email addresses. Initially, because you had to scroll through all of them, you got this sort of fascinating look at what people were interested in talking about online. I joined a Sri Lankan culture group and a few literary and sci-fi ones. It felt like being at a Star Trek convention constantly.

Then I discovered the sex newsgroups. It was the very early days of information-sharing, and anything went. There would be threads where people would be like, "What's the most durable condom?" I could talk to strangers in the middle of the night and I could post that I wanted to have a threesome or fool around with women, and then five people would chime in saying, "That's the best thing ever." It gave me this amazing source of freedom because among my friends at U Chicago, there was still this pressure to be a good girl.

Then I started reading the erotica people posted, and it was the first time I'd ever read a lot of bad fiction. I was a little frustrated because it was so unrealistic. The characters didn't seem like real people. I thought, Well, I can do better than this. So I decided to write my own story, a terrible story in retrospect, called "American Airlines Cockpit." It was about two college girls on a plane to England and it was loosely inspired by a vacation I had taken with my best friend from high school. Only, in my fictionalized version, the two girls get bored and decide to go entertain the pilots.

I think I was just trying to write something fun and silly. But after I posted the story, people started writing comments—it wasn't really comments, it was threaded replies back then—and emails praising my work. People loved it—probably just because I could spell and it was easy to read. I was an English major and I loved literature, but it had never occurred to me that I could be a writer. But in that moment, on the Internet, it felt like a possibility.

Over the next year, I wrote probably twenty or thirty stories and posted them online. I was interested in literary stories where I could use depictions of sexuality to reveal character. They became outlets for me to test my sexual boundaries, or imagine a different path for myself. There was one story I wrote called "Season of Marriage," about an Indian-American girl who goes back to India for an arranged marriage. On her wedding night, she has sex with her new husband, Vivek, for the first time, which turns out to be far more intimate and tender than she had foreseen. It was inspired by a friend I'd grown up with who'd had an arranged marriage. I kept thinking about her, even though I didn't know her very well. Maybe because her story could have been mine.

One day, my parents got a call from a relative in England. "You know what your daughter is putting on the Internet?" he asked them. To this day, I still don't know how he found my stories. But all my parents could think to say was, "What's the Internet?" My father was furious. He actually called me and demanded that I take it all down and I tried to explain to him that I couldn't do that because I had no control over how the stories spread. I don't think he believed me, and to be fair, I don't think I really wanted to take them down, anyway. He wanted me to stop using his last name because he felt I was tarnishing it. But it was my name, too, and for the first time, people saw it and thought of a writer.

My parents and I became very distant for several years. They threatened to send me to a convent in Sri Lanka, but they valued education just enough that they were not willing to pull me out of school to force my hand. It made life very hard for them for quite a while. They asked me to not come to social events in Connecticut, where they lived, because they thought my presence would make it harder for my sisters to find husbands.

I kept writing stories, and when Paul and I broke up, I started relationships with both men and women. I had threesomes and I knew I didn't want to be monogamous. I'd seen that people in the newsgroup had had successful polyamorous relationships, so it wasn't just something out of a sci-fi novel. In my junior year of college, I met my now-husband, Kevin, in a threesome with another woman. She moved away, but Kevin and I fell in love. My parents and I sort of muddled along. They came to my college graduation and they didn't love that Kevin and I were dating, but they were stiffly polite to him.

After I graduated, I worked as a secretary during the day and continued writing erotica at night. When I started blogging, I received hate mail for writing about sex. Men in India told me I was ruining the dignity of brown women. My resolve to keep going only got stronger. Eventually, I sold a book of short stories about Sri Lankan mothers and their daughters to HarperCollins. "Season of Marriage" was the story that sparked the idea for the book. After I received my advance, I sent my mom a copy of the check to reassure her that I was being paid real money to write. Slowly, she and my dad began to see that I was making it on my own, and that my writing erotic fiction didn't turn out to be the end of the world.

When Kevin and I had our first child in 2007, I wanted to give her a Tamil name. We decided on Kaviarasi, which translates to "queen of poetry." She goes by Kavia, or "poem." I think the name meant a lot to my parents. They threw a party to show her off to their community, and all the Sri Lankan folks in their neighborhood came.

Kavia is twelve now, nearing an age where she'll be discovering sex soon, if she hasn't already. Sometimes I wonder how to talk to her about it, and how to warn her about the right things—not the things my parents decried, like how dangerous and corrupting it would be. Instead, I want to tell her it's incredible, a shock to the system, a tidal wave of ecstasy.

Interview by Natalie So | Photographs by Mel Brunelle

Mariela Machado Fantacchiotti

+

Hertzen Villela

Mariela: When Hertzen and I met in the summer of 2011, it was a total disaster. Our friends had been telling us about each other for years when they finally introduced us one night at a bar in Caracas.

Hertzen: I thought she was very attractive, but she was there with her boyfriend, so I wasn't about to try anything romantic with her. I'm respectful like that.

Mariela: We were having a really deep, intellectual conversation when I made a joke about Germans being square. Hertzen's family is German, so that didn't go over well. He got back at me later when I mentioned I was interested in anthropology, and he was like, "You would make the worst anthropologist." I was furious.

Hertzen: I made an impression.

Mariela: I kept running into him at parties and we always ended up talking to each other like the room didn't exist. I started to warm up to his sarcasm. Then I heard from a friend that he said something like, "I have to stop hanging out with this group because I'm falling for her."

Hertzen: I moved to New York for grad school, but also to be with a girl I was dating. She broke up with me during my first semester. All the friends I'd made in New York were people I knew through my ex, so I was pretty lonely. One day I was telling my friend in Venezuela about my situation and she mentioned that Mariela was also in New York. I was like, "Wow, is it okay if I contact her through Facebook?"

Mariela: I'd gotten into a master's program for developmental engineering, but mostly, I just wanted to get out of Venezuela. Nicolás Maduro had taken power and police were shooting protesters in the street. It was really going down the drain. I was surprised to hear from Hertzen. I had no idea he was here, too. I was single, but I had just broken my ankle and I didn't want him to see me in a wheelchair.

Hertzen: I was like, "Do you want me to bring you chicken noodle soup?" She kept turning me down. I didn't get it. Finally, a few weeks later, she invited me to watch a Venezuelan football game at a bar. I showed up and she was there with two other friends! She sat on the other side of the table and kept encouraging me to talk to them. I was like, I came here to see you!

Mariela: I was testing him!

Hertzen: Around that time, I had a dream about a girl with a twin and a broken ankle. Which is crazy because I didn't even know Mariela had a twin back then. In the dream, we both got our visas, which I took as a sign that we were meant to be together.

Mariela: Then he invited me to a Fourth of July party on his rooftop in Brooklyn. It felt like a big step.

Hertzen: I was hosting it with my two roommates, who were these rich, bratty Venezuelans who partied all night and slept all day. I never brought girls around, so they didn't believe Mariela was actually going to show.

Mariela: I was about to get in a cab to go to Hertzen's place, but at the last moment, I said, "I cannot go. I'm in pain." I wrote to him when the party was about to start.

Hertzen: She wrote to me an hour after the party started saying that she couldn't go, that she had another party to go to or something! I couldn't believe it. My roommates were laughing about it. They thought I had made Mariela up.

Mariela: He was so mad. He stopped messaging me! I took an internship in San Francisco and we didn't speak for almost a year. After I graduated in May 2016, I got up the nerve to invite him to a party at my sister's house. For some reason, I had never mentioned to him that she was my identical twin.

Hertzen: I'm a psychologist, so I was like, "Oh my God, this is an interesting case."

Mariela: My sister called me after the party and said, "That guy is totally into you." But he was so shy, I still thought maybe he just wanted to be friends. So, as a test, I decided to invite him to this Latin party called Bomba Party, where they play merengue and salsa and reggaeton—the kind of music he hates.

Hertzen: In Venezuela, if you want to get the girl you have to know how to dance. I was like, that's not really my scene, but I'm gonna do it. I'm gonna dance with her.

Mariela: One night soon after, we were standing in front of my apartment saying goodbye and he kissed me. We kissed in the middle of the sidewalk for ten minutes. At least that's what it felt like. He looked me in the eyes and said, "You and me will end up together, and your visa will be approved." He said it came to him in a dream.

Hertzen: We wanted to be together, but we knew that if our visas didn't work out, the relationship would be over. Neither of us wanted to go back to Venezuela. In New York, there's always something new happening.

Mariela: We were in love, but our country was destroyed.

Hertzen: Then, on top of everything, Mariela got thrown out of her apartment.

Mariela: I still don't know why. I didn't even do parties or anything. But suddenly, we had to bet everything on staying. So we decided to move in together.

Hertzen: In Venezuela, it's really not typical for couples to live together before they're married, so that was a big deal. Mariela is much bolder than me, so I let her take the lead. It was a leap of faith.

Mariela: A month later, I found out my visa had been approved, but we still didn't know about Hertzen. We waited in total suspense. We drank a lot.

Hertzen: I still remember the day I got my acceptance letter. The fax came in to my office and I had to check it like a hundred times.

Mariela: Now we're working toward getting our green cards. That will be like the second step of happiness. We want to sit and watch movies, go to concerts. But we don't want any more excitement. We just want a boring life together.

Interview by Julia Black | Photographs by Valerie Chiang

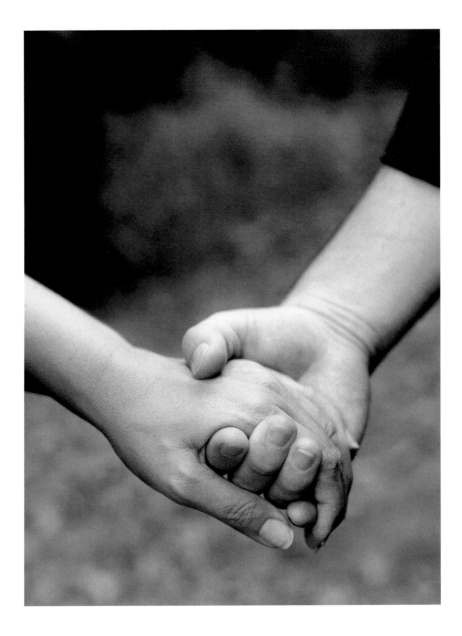

Giorgio Kolaj

———

We were Albanians from Kosovo. That was part of Yugoslavia then. It was a strict Communist regime, a dictatorship. There was ethnic conflict in that part of the world. Albanians are Muslim. Serbs are Christian. During World War II, when my father was a young man, the Serbian Partisans came through his village and slaughtered my grandfather. My father's father. They chopped him up, and my family only discovered what happened to him when a shepherd found his hand with his wedding band and brought it back to them.

Under Communism, life was hard. My father and my mother never went to school a day in their lives. They were both farmers, and their parents were farmers, and their parents' parents were farmers. My father had to teach himself to read and write. I sometimes think about my father and ask myself: What gave him the idea to leave? In Communist Yugoslavia, you didn't have ideas. It was dangerous to have ideas. To even think that the West was better was outlandish.

And how would he even know to think such a thing? All the propaganda told them: Communism is the only way. The state news in those days showed America as a hell on earth: race riots, crime, the war in Vietnam. It was the '60s. I wonder: How could my father know otherwise? But something stirred so deep, so profoundly, that he knew he had to leave. He sold the farm. My mother tells the story about how she was absolutely terrified. They had four children. This was the only world she knew. That's where her family was. Her brothers, her sisters. She did not know how to read. She had never ridden a bicycle. She had never tried to swim. She did not know what America was.

There were underground routes out of Kosovo. Other Albanians had gone before us. They sent handwritten letters back telling the way. My parents received letters from Italy. So they went there. Luckily for us, Italy was taking in immigrants and refugees from all over, and we waited there for our paperwork to come in from the United States.

My father had arranged for us to stay on a farm. It was what you might call a feudal arrangement, but the owner of the farm was a wonderful Italian gentleman named Armando DeLuca. He needed farmhands, so my father, and later my uncle and my aunt, would receive free room and board in exchange for our farming services. That's where we were going to stay until we could go to America.

My mother was a superstitious woman. She saw signs. She saw omens. On that farm, she had a premonition. One day, Armando dropped off my father at our house in his white station wagon, like he did every afternoon. But my father didn't come inside. My mother went to the balcony and saw my father. "What are you doing?" she asked. "Why haven't you come up?" And he said, "Go back inside, because the baby needs you." I had just been born. I was not even two months old. After some time, my mother went to the balcony a second time, and my father was not there. No one was there. And then she sees Armando and his white station wagon pulling up to drop off my father! She told my father she had just spoken to him. "What are you talking about?" he said. "I was in the fields," he said. "I was not here." My mother knew this meant something bad would happen. She thought it was a bad omen.

A month and a half later, in November, my father fell from a tree while picking apples for us. His injuries were bad, and they called my mother to the hospital. She sat by him for six days. Her hands were at my father's feet. My father knew she was scared. She would want to escape back to Yugoslavia. That was all she knew. But my father's dying wish was for her to continue on to America. On his deathbed, he told her, "I will haunt you from my grave if you go back." He knew she was old-fashioned and she believed in those things. She had no one there in Italy. She had no one in America. All she knew was my father's dying wish. She did not want to go, but she knew she must carry out that wish.

We got our paperwork to come to the United States, but we had no money at all. The town took up a collection to bury my father. And Catholic Charities gave us a $280 loan to buy plane tickets to New York. My mother had never been on a plane. Before Italy she had never ridden on a train, or even in a car. Just a horse and buggy. She never saw a telephone until Italy. Catholic Charities drew up a promissory note for the loan. My mother didn't even know how to sign her own name.

We landed at JFK. We did not know where to go. Social Services came, and we were settled in the South Bronx. In 1970 in the Bronx there was no need for farmers. So we grew up on welfare. We lived at 575 Castle Hill Avenue. I still see the building when I fly into LaGuardia today. If you're coming in from the west, and you fly over the bridge, and if you happen to be sitting on the right side of the plane, you'll see about five or six red brick buildings, on the very tail end of the Bronx, right by the water. Those are the projects where we lived. That's where my brothers and sisters and I used to lie in bed and watch all those planes coming in for a landing, touching down in New York.

My mother always dressed in black, out of respect for my father, like widows in the old country. I saw my mother only in black until I was seventeen or eighteen years old, until my first brother got engaged and there was a party. In 1986, I took my mother to visit my father's grave. I had never seen it myself. We walked around the village cemetery, looking for the one Albanian name. We found him buried in a mausoleum, and here's the thing: The white marble was clean, and there were fresh-cut flowers. I turned to my mother and asked, "Who is taking care of dad's gravestone?"

We went to find Armando at his farm. It was an August evening and the sun was setting and the fields were washed in gold and I see this one man in the fields—believe it or not—carrying a sickle in his hand. In my broken Italian, I yelled to explain who we were and he was already weeping. Yes, he said, he was still taking care of my father's grave fifteen years later. He invited us to his home, and I wanted to give him a gift. I had only $500 to my name. I took it all out of my pocket and said, "Mr. DeLuca, I would like you to have this." "What is that?" he asked. "For all these years of fresh flowers," I said. "I want to give this to you." He looked at me and said, "I would rather that you slap me in the face. I would never take this money." Later, Armando took me up a mountain on his farm, a big hill where he had a lot of billy goats. We looked at the land together. He was a real farmer. A real gentleman farmer.

In the Bronx, I learned a lot. I had the privilege of being poor. But I also had the privilege of being raised in the most culturally, ethnically, religiously diverse society in the world. I've seen racism, but I've seen beautiful things. One day when I was a boy, a woman knocked on our door at our house in the Bronx. This was unusual. My mother jumped up and we all followed her to the door like baby chicks following a hen. And there was an African American woman with an old shopping cart. My mother undid the chain and the woman pulled out some boxes, which she opened to reveal . . . hamburgers. She came in and we sat there, not knowing what to say. My mother couldn't say anything in English. There we sat, eating together with this mysterious woman. I thought I had hit the lottery. I never saw her again. I still don't know why she came.

Interview by Joshuah Bearman | Photographs by Mark Hartman

Karis Wilde

———

On my eighteenth birthday, my best friend gave me a Hula-Hoop and I fell in love with it. I was living with my mom in an apartment in the San Fernando Valley and I'd Hula-Hoop every day in the living room. At first, I was Hula-Hooping to let all the aggression out. You can't be pissed off when you Hula-Hoop, you know? But the more I practiced, the better my spatial awareness got, because I didn't want to break anything in the apartment and get in trouble with my mom.

We'd moved here from Mexico when I was two. My mom was escaping a really awful marriage and she just wanted more for herself and for me and my brother. All of my extended family still lives in Tecate, and when I was younger, they'd see photos of me and gossip about whether I was gay. There was always like this rumbling, rumbling, rumbling. The gossip intensified when I started making all my own outfits. I'd wear halter tops and platform shoes and even in L.A. I got picked on nonstop. It was the late '90s and the term *gender-fluid* didn't exist yet—it's only now that the language has caught up to me.

One day, my best friend and I were Hula-Hooping at a barbecue, just messing around, and this belly dancer came up to us. She was like, "Listen, I have a show coming up and I would love for you to be in it." My friend and I didn't know what to expect—neither of us had ever performed for an audience before. We just thought, Okay, we've got to make this good.

We needed something skimpy to wear because the Hula-Hoop grips better to your skin than it does to fabric. So I sewed these matching outfits, which were basically just a loincloth and oversize kimono sleeves. When we came out onstage at this club in Hollywood, we had our arms crossed, and then slowly opened them like a kind of unveiling. We were holding these torches—this was back when clubs were more lenient about fire codes—and we were just dancing around, and then we started Hula-Hooping in sync together. The crowd lost their shit. After that, the phone started ringing off the hook with people who wanted to book us. We slowly but surely started doing our own thing.

It's pretty funny because to tell you the truth, I don't do any of the harder tricks. But I'm really good at showmanship. I understand how to be fluid. Sometimes I feel a lot more feminine and sometimes I feel a lot more masculine. And you'll see that not only with what I wear, but how I act and how I throw my body around. I get very offended when anyone calls what I do drag. Because to me, drag is about creating this other persona. But when I perform, you get an extension of who I am.

When I was twenty-one, I got hired to Hula-Hoop at this wrestling show called Lucha VaVoom, where they have burlesque performers and all these different types of dancers. My first show was so terrifying. But once I got on stage, I felt the love. I don't know what happens to me, but when I get on stage and Hula-Hoop, I completely black out. Luckily for me, my autopilot says, "Take off your clothes and Hula-Hoop." Before I know it, I'm walking offstage.

The woman who ran Lucha VaVoom, Rita D'Albert, had been in the burlesque world for a long time and pretty quickly became my drag mother. Rita saw potential in me and pushed me to go wild with my imagination. When I would tell her my ideas, she would say, "What else can we add to it?" I was like, "Bitch, I already added everything to it." And she'd be like, "No, we would need more."

One of the hairdressers on the show was good friends with this up-and-coming fashion designer and he asked me if I could Hula-Hoop at the beginning of his show at Fashion Week L.A. His financial backers were very nervous about it, so he had me come in a couple of days before to show them that I could Hula-Hoop. Of course the Hula-Hoop went flying and everyone was terrified. Paris Hilton and a bunch of other celebrities were supposed to be in the front row, and they were like, "He's going to kill someone!"

But whatever, I did the show anyway, and that's how I ended up meeting Madonna. It turns out her stylist was in the audience, and she pulled me in for a last-minute audition for her Confessions tour in 2006. I went in and I showed one of her dancers everything I knew within a week. They literally sat me right in front of Madonna while she practiced the choreography, and I was such a big fan that I teared up. It was one of those moments where I felt like, Okay, I'm on the right path. Pretty soon, I was traveling the world as a Hula-Hooper.

One time, I was in London and my friend called me up and said, "Hey, do you want to perform for Björk at her after-party?" She was playing in Manchester, so I got on a train with my Hula-Hoop and went to the concert. I remember listening to her sing this song that I used to listen to as a depressed little kid wanting to kill myself. I started to cry; she had shaped my life. I went to the after-party and got in costume in the bathroom and I popped up and did my thing. Later on in the night, she asked me if I could dance again. Of course, I agreed.

At some point in my twenties, I got interviewed by a Spanish television network, Univision or whatever. They made a little segment about me and my aunts and uncles all saw it. They work in my grandfather's restaurant in Tecate, so the TV's always on in the background, and they recognized my voice because I used to skip my words a lot and say, "Um, um," especially when I spoke Spanish. For me, this TV segment was really not a big deal—it was at the bottom of the list of important things I've done—but to them, it meant a lot. They were really excited that I seemed to pop up out of nowhere.

The next time I visited Mexico, they all wanted to hear more about my life. They were like, "Oh, my God, we saw you!" But it just felt like too little, too late. It was like, This TV segment is why you like me? It was this moment of feeling like I was finally being viewed as a grown-up, but then realizing, their approval meant nothing to me. I think that's how life works, though. Nobody wants you 'til somebody wants you. Then everybody wants you. But I've been doing this all my life. Nothing has changed.

Interview by Jennifer Swann | Photographs by Enkrypt Los Angeles

Gideon Oji

———

When I was growing up, my mom sold *akara* on the street. It's a deep-fried ball made out of black-eyed peas that she served in old newspapers, folded like a plate. Each one is the size of a chicken nugget. It's my favorite food in the world. I think I have eaten more *akara* than anyone else on the planet. Every day after school, I would go and sit with my mom and just eat and eat for hours. She would ask, "Where does all that food go?" Lucky for me, I'm 225 pounds no matter what I eat.

When I was seventeen, an American guy came to my village in Nigeria to run a basketball camp. I was more of a soccer player, but because of my height people were like, "Hey, go play basketball." I wasn't very, very good, but I was 6′9″ and athletic, so the coach said, "Would you like to come to America and go to school?"

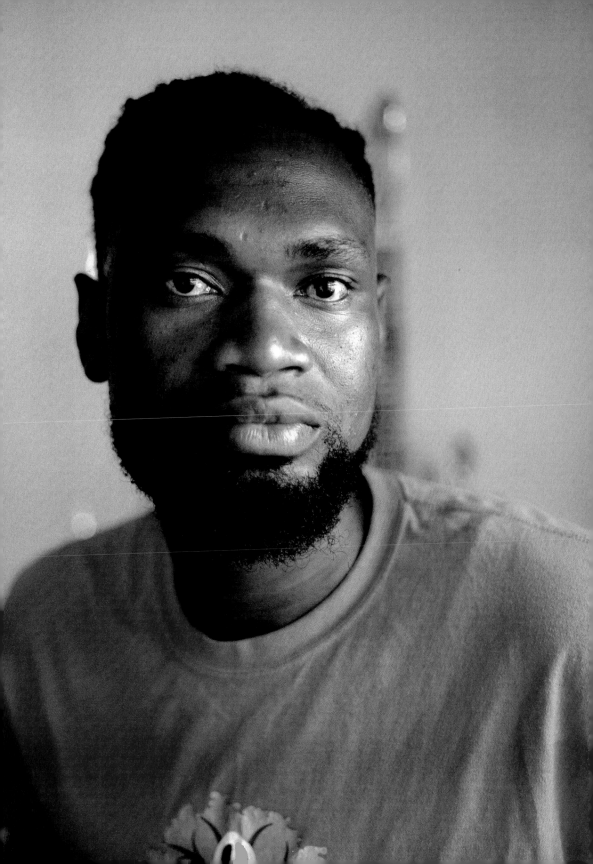

In the fall of 2009, I arrived in Roxboro, North Carolina. I was surprised because I thought it would be a big city, like the ones I had seen in movies like *Coming to America*. I lived with the pastor's family from the church that sponsored my scholarship. They were very good people, but they served so little food at dinner—usually a small piece of steak and a little bit of mashed potatoes. I'd think, God, I wish I had more to eat.

That summer, I read about Nathan's Hot Dog Eating Contest in a newspaper. Joey Chestnut ate sixty-eight hot dogs in ten minutes—a new world record. I had never seen a hot dog before, all that meat mixed together and stuffed into a sausage casing. I thought to myself, Why ruin meat like that? But then I thought, I bet I can do that.

I transferred to Clayton State University, where my girlfriend Elizabeth was in nursing school, to play on the basketball team, in August 2014. My team did well—we held a 15–12 record that season—but I couldn't stop thinking about Nathan's Hot Dog Eating Contest. When the season ended, I went online and signed up for a contest just a few miles away, at the Atlanta Dogwood Festival.

My whole life, my mom never understood soccer or basketball. She didn't know why I wanted to throw around a ball all day. But when I called and told her about this eating contest, she said, "This is tailor-made for you." She had seen how I was a garbage disposal at home. When she gave me her blessing, it gave me a reason to go out there.

To practice, my teammates and I cooked up a bunch of hot dogs in my dorm-room kitchen. They put ten minutes on the clock and I began to eat, one hot dog at a time. With one minute remaining, I finished all twenty. My teammates went wild. I realized I was nowhere ready to compete against Joey Chestnut—he could eat sixty-eight hot dogs in ten minutes—but I could probably hold my own in a qualifying event.

When I arrived at my first contest, I noticed a man wearing a fedora, with dreadlocks that fell to his shoulders. His name was Crazy Legs and he was one of the top twenty-five competitive eaters in the world. He gave me some advice: Don't rush. Pace yourself. Then he said: "I'm going to beat you anyway."

When the competition started, I ate each hot dog as fast as I could, but I had no idea how I measured up. I had no game plan and no strategy. It was only in the last two minutes, when the emcee began yelling my name, that I realized I was right behind Crazy Legs.

When the timer went off, I'd eaten twenty hot dogs, and Crazy Legs had just shoved a twenty-first into his mouth. I resented the advice he gave me, which I realized was a bunch of crap. But my resentment motivated me. Now I had someone to beat.

When I saw that Crazy Legs was competing in a corn-eating contest in West Palm Beach, Florida, the following weekend, I knew I had to sign up. I only had enough gas money for a one-way trip, but I grew up eating tons of corn on my family's farm, so I was betting on winning the first-place prize: $2,500.

When the clock started, I watched as my pile of chewed-up cobs grew bigger and bigger. When time was up, Crazy Legs began arguing with the judges, trying to talk them into counting cobs they'd disqualified. It was just a whole lot of mess, and everything was happening so fast. The judges deliberated for forty-five minutes, then announced that Crazy Legs had placed second. I came in third. My $800 check was more than enough for gas and tolls on the way home.

After college, I only took jobs that would give me the time off to compete. That usually meant the shipping line at warehouses like Walmart. I drove forklifts, I packed boxes. By the time I finally beat Crazy Legs at a Hooters wings contest in Florida, I didn't even see it as a big victory. I wanted to beat my real rival, Joey Chestnut.

Elizabeth and I had gotten married that year and she hated that I was gone so much. She came with me to competitions at first, but now, she would stay home and call me every time I was on the road. She always wanted to know my exact location and what I was doing.

In 2016, I came home from a contest in Chicago and saw her Facebook page open. She'd been talking to this guy, and when I confronted her about it, we fought and she threw me out of the house. She blamed me for neglecting her with my eating contests. I stayed on my friend's couch for a while. We were on and off for a long time, and eventually, our marriage dissolved.

Competing was so painful after that, even though I was performing so well. Nobody knew what was going on inside me. At the same time, I was consistently winning contests, and pretty soon I got my chance to compete against Joey Chestnut, at the annual kale-eating world championship in Buffalo, New York.

Kale is not something that you can easily swallow. Eating massive quantities of it requires a lot of mental and physical strength. Luckily, I grew up chewing on stalks of sugarcane and eating goat knuckles. I would crack the bone with my teeth and spend hours fighting to get a piece of meat from the bone.

When the kale-eating contest started, I rushed so much that I almost choked. There was a big ball of kale stuck in my throat. Then, out of the corner of my eye, I saw Joey scarfing down kale. So I shoveled more into my mouth and picked up speed.

After eight minutes, the buzzer rang and the emcee called Joey and me up to the front of the stage. He said, "One of these men ate twenty bowls of kale. One of these men ate 22.5 bowls of kale." Then he announced it, "Your winner, and still the world's healthiest eater: Gideon Oji!"

Joey and I hugged, and I jumped up and down. I was so happy. Joey said to me, "I don't know how you do it, man. I was struggling."

It's been four years since then and I am now ranked in the top ten competitive eaters in America. Eating still doesn't pay the bills, but I hope one day it will. For now I work in the shipping line at a Target warehouse. It's a lot of paperwork and logistics, but it gives me the time off to compete.

One day, when I win Nathan's, and I have enough money, I will go visit my village in Nigeria. I will eat my mom's *akara* again. I will travel around and eat all the foods from different regions in Africa. I will stop by someone's house and say, "How about I buy you a goat? Show me how you cook it. Make soup with it, or whatever. Share your recipe with me." We'll eat together, and it will be so exciting.

Interview by Natalie So | Photographs by Valerie Chiang

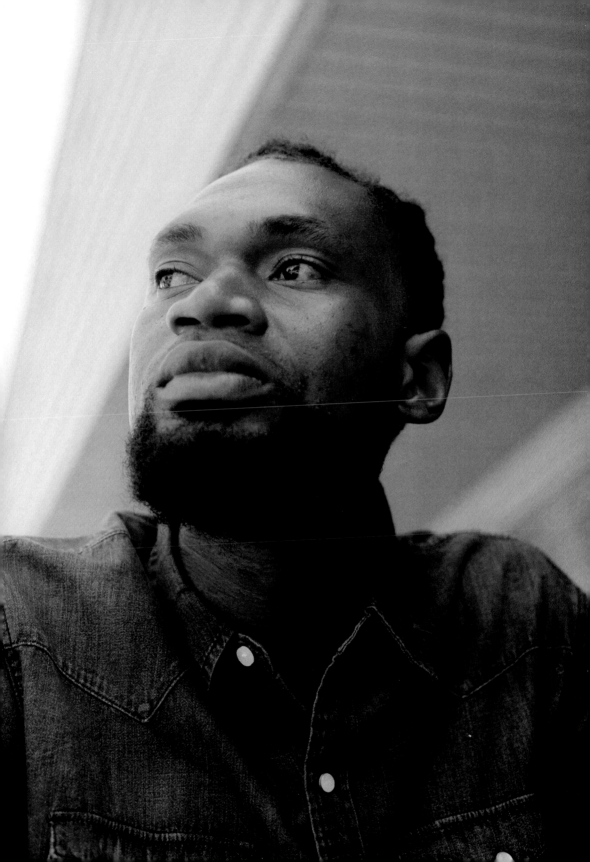

Igor Pasternak

———

I've been making blimps since I was a child in the Soviet Union. This was the late '60s, and we lived in Lviv, Ukraine, near a meteorological station. They worked with balloons, and I loved to see them lifting into the sky. I became friends with the supervisor of the station. I asked so many questions. How does this work? And he'd say, "Go away, Igor." How does that work? "Not now, Igor." Until one day, he said, "Come here, Igor. Let me show you how they work."

The first thing I put in the sky was a hydrogen balloon. The balloon was not tethered, it was free-flying. Those balloons go 60,000 or 70,000 feet, and they transmit information back to earth with radio frequencies. We watched the numbers come in—atmospheric pressure, temperature, wind speed. It was so exciting. I've known what I want to do since I was six years old, and it has never changed.

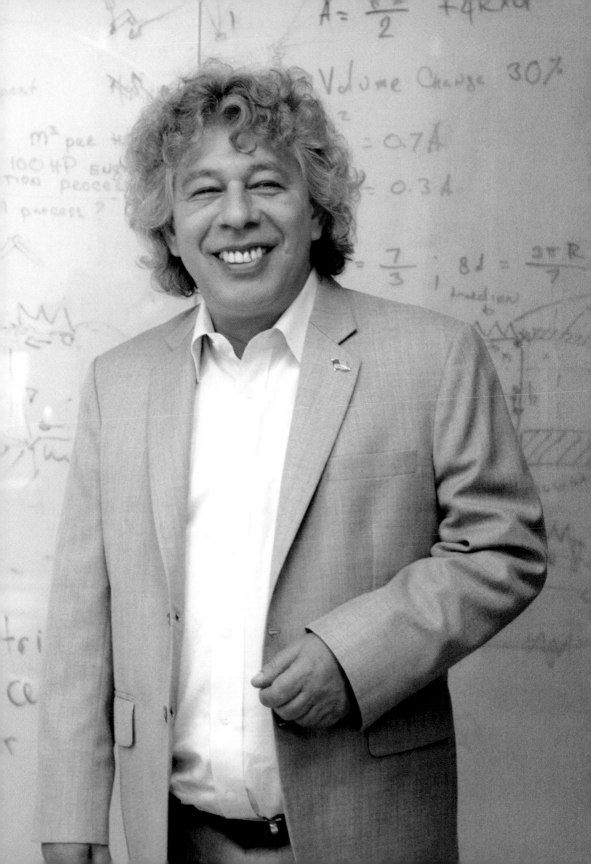

As a kid, I went to the library and checked out all the books on airships. I began designing. And not just drawings—calculations and detailed plans. My friends knew, "Igor is the blimp guy," and they would see me going to the park with my homemade balloons, trying out new things. When I was a teenager, I went with my friend to a conference of Soviet avionics experts. We talked our way in. No one understood why we were there. At university, I became an engineer. But I could not study aeronautical engineering because my parents were Jewish. They called them refuseniks. I had to study civil engineering. After school, I still wanted to make airships. You know, it's hard to remember what inspires a young man, but at the time, airplanes were flying, the rockets going into space, but no one was working on airships. There was a lot of innovation in aerospace. But airships were left behind. I felt a hunger to create something new, and a kind of self-determination to express myself as an aerospace engineer. But no one built airships in the Soviet Union. Everything belonged to the government. There were no market forces, no private enterprises. So you cannot even start your own company to build airships. It was impossible.

My father came to the U.S. before me. He was an engineer. My mother, too. And my sister. A whole family of engineers. In America, I got certified by the FAA to build airships. It was 1993, and I went to California, near Castle Air Force Base. I built airships for the Defense Department. And then I moved to Los Angeles. My sister, she became my partner, my right hand. My father also was very active, coming in every day to work with us. Together we became the biggest builder of airships in the U.S. The creation of these air vehicles, this route, this success you cannot achieve without family. It was all of us together.

Blimps, for me, is about personal expression. Planes are planes. You can make better landing gear. You can make better wings. But you cannot change the plane. I want to design something that no one has done before. I want to make an entirely new vehicle.

You see, a blimp is very impractical. To land the Goodyear Blimp, you still need guys with ropes. I want to build a ship that controls itself. This is a very old problem. Oldest in flying. First flight was hot air balloon, for Louis XVI! They flew a sheep over Versailles. You still have the same engineering problem for airships as then. No one has solved it. Everyone has tried. Everyone failed so far. That is why the sky is not full of blimps!

I was playing with equations, and I realized: This can be done. I do calculations by hand, on pen and paper. I have fifty or sixty engineers working on my new airship. The full version will be 787 feet. It will be able to fly 5,300 miles. People say it's not going to work. But if it works, it could change the world.

I am building my new airship in Tustin. In California, near Los Angeles. There is a giant Marine Corps hangar, from World War II. I drive down to see progress. Yes, my driver takes me. He is also Russian. Everywhere, Russians! I made a modified SUV to be my office, so I can work longer. I eat in the car, read in the car, look at plans. From Beverly Hills to Tustin. The car has Wi-Fi and flat-screen. And a bar, for after-work cognac. Also, cigars. And my glasses. I have many pairs. In the car, at the office, at home, at the airship. I lose my glasses all the time, so I have dozens of pairs made—hundreds!—and I leave them everywhere.

Everyone knows I am a workaholic. Yes, I am married. On my third one. I stay up late. I can't sleep. I see equations. I am sixty-four now. My sister, she has passed. She was working on the airship. It was a tragic event. We made a memorial in our engineering conference room. It's a dedication to her. A dedication that is always with me.

My father is still an essential part of the business. Last week we celebrated his eighty-years party. And my son is a blimp designer, too. At seven years old, he was making plans. He has good ideas. It's impressive. I bring his plans to my engineers.

Do I know how to fly the craft myself? Of course. But I am not licensed. I do not pilot the airships. I like to go up. Every first flight, I am there. Every time you're inside a ship, and you feel it lift from the ground, it's an unbelievable feeling. You can live for this feeling. The biggest high is when a new craft takes off. It is like you are an addict for this feeling. No, you are absolutely addicted. Then there will be another one, and you will look for that feeling again. This is the reality. You don't know what the hell else you can do in this life.

Interview by Joshuah Bearman | Photographs by Kathryn Harrison

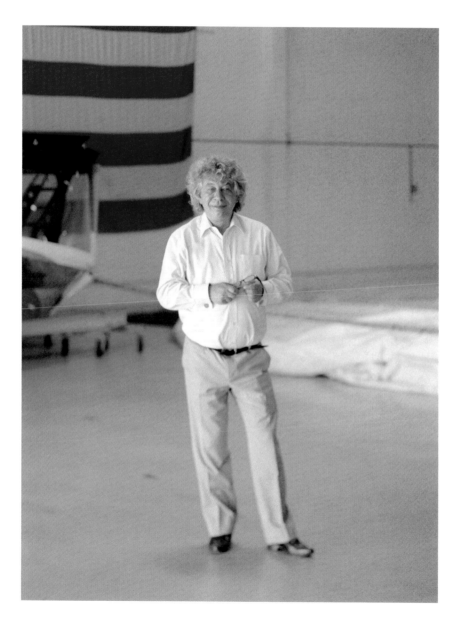

Kunal Sah

———

I was five years old when we moved into the motel in Green River, Utah. My family had immigrated to California from India in 1990, and for seven years my father worked odd jobs: dishwasher at Pizza Hut, burrito-roller at Taco Bell, line cook at Jack in the Box. He saved every cent to buy that little motel.

I'd follow my parents around while they cleaned rooms. I put on pillowcases and folded towels and made sure there was fresh toilet paper in the bathroom. When it was lunchtime, my dad would run to Arby's in the little Nissan Sentra he had and get ten bucks' worth of food. It'd be chicken tenders and some potato cakes and curly fries and mozzarella sticks, and we'd eat. Then we'd get to working again.

We worked on that Budget Inn for about four years. My parents wouldn't hire any staff. They were just saving money. They saved and saved and finally had enough for a Ramada Limited. My father bought some land, had a hotel built from the ground up, and in 2002 was issued the Ramada franchise banner.

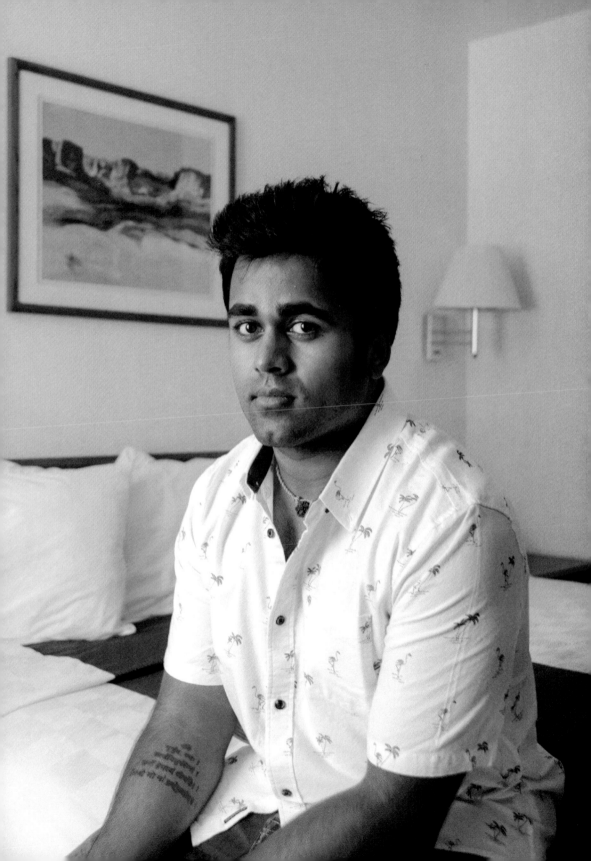

All my other friends in town, they were always just getting yelled at by their moms and dads. But my mom and dad, they knew how to do it right. When I finally got the hang of riding a bike, my parents had a manager cover for both of them so we could all ride together. Sometimes my dad would get this look of conviction in his eyes, and he'd look at me straight and say, "You are the best in whatever you do. You can be the best. This is all up to you now. This is all up to you."

I still remember the day, July 7, 2006, when they packed their bags. My mother and father had been fighting a deportation order they received in 2004, and their citizenship had been pending for fourteen years. I was eleven years old. They were not being deported on the basis of criminal activity. They were being deported just because their citizenship application was in queue since 1990 and their time was up.

My dad asked his brother to move to Green River to be my guardian and take care of the Ramada. But living with him was a nightmare. If I missed the bus or came home five minutes late from school, I would get in trouble. I was a 4.0 student; I wanted to go to an Ivy League college and then become a neurosurgeon. That was my goal. "You can't do that." That's what he'd tell me. "You cannot be a doctor. You can't." That was the only grownup voice I had in my household, telling me that.

I had made a minor career out of competing in the Scripps National Spelling Bee. My eighth-grade year was my last chance. I was desperate to win. I wanted to bring attention to what happened to my parents. For ten hours a day I'd sit with my Webster's *Third New International Dictionary*. It's 2,600 pages, and I would go page by page writing words down that were new or challenging to me. I'd study roots and languages of origin, prefixes and suffixes.

I made it into the finals that year. We went to the White House so they could film a segment to introduce the spellers, before the prime-time broadcasts. We met Laura Bush. Everyone was given a chance to introduce themselves to the First Lady. When my turn came, I said, "I am Kunal Sah, and I want my parents back. I really need some help. Please." I was sitting on the floor in a circle with all these spellers, and I started crying. "All these kids here that are with me, their moms and dads are here. Mine should be, too." That's all I told her. Mrs. Bush walked over and consoled me a little bit; she said, "This is something that we can address if you write to my office." It was a generic answer. "Write to our office"? "We'll address it"? Come on. I had been doing that for the past two years. My dad had. My mom had. I had written to congressmen—Jim Matheson and Orrin Hatch, and all of the representatives of Utah. A few years later, I'd write to Obama's office nearly every day.

I was the first one eliminated in the final. I ended up taking thirteenth.

I returned to Utah depressed, afraid, angry. This is my parents' house, I thought. My dad built this from the ground up. This is their place. I turned twelve and then thirteen, fourteen, and fifteen years old, each day playing the role of my mother and father. Trying to maintain my GPA, but more importantly, keeping their business afloat. My uncle would be drinking beer on the lobby couch, and I'd be doing hotel laundry, washing and drying the linens, renting rooms. Setting up breakfast in the morning before I took off for school. It was just overwhelming. It was too much.

My uncle went to India for a few weeks, leaving me to run the hotel full-time. I hadn't seen much of anyone in days, so when friends asked if they could come hang by the hotel pool, I told them sure. They arrived with a rack of Budweiser. I figured it'd be okay; it was a slow night. I cracked a beer. Within an hour, the cops arrived. We weren't being rowdy or loud. Some kid who hadn't been invited tipped them off. But because the drinking took place at my house, I was the one charged with serving alcohol to minors. It didn't matter that I had good grades and no previous charges; that my teachers thought highly of me and that I wanted to be a doctor one day. I was sentenced to forty-six days in detention. Suddenly I'm in a jail cell at fifteen years old. It was my sophomore year and I was kicked out of school.

When I was released, I was placed in foster care for two years, in a town about an hour outside Green River. I finished my senior year of high school online. I never got a graduation ceremony. I never got a prom. I didn't go to college. When I turned eighteen, my uncle called. "I don't want to do this anymore. I can't do this. I'm leaving. I'm leaving your property and you can do what you want with it."

I returned to Green River to take over operations. In my more-than-two-year absence, the hotel had been neglected. Every aspect of the place. The walls were damaged. The carpets were stained. Stucco was chipping off the outside of the building. The roof was missing shingles. The pool and hot tub were disgusting.

I found myself in a daze. I'm talking to the banks, I'm talking to my accountant about things and I don't even know what they mean. I don't know what quarterly tax is. I don't know any of this shit and it's all just blowing over my head. I'm lost, not knowing what to do or who to call. The hotel is everything. It was, it is, our home. We lived in an apartment right behind the front desk. And I just don't know what to do.

So I start with what my parents and I did together when I was a kid. I put on clean pillowcases and sheets, fold fresh towels, and replace the toilet paper. And then I pull hair from the drains, scrub the walls and carpets, rake the leaves, and sweep the dirt around the pool. But most importantly, I'm at the front desk. I'm on the phone. I'm there. People see my face and they hear my voice and they have the assurance that their lodging will be okay.

In 2015, my dad calls and says, "I got a letter from the United States Citizenship and Immigration Services. It has interview dates for me and your mother. December 8." I couldn't speak. I just hung up the phone and sat there. I looked around and thought, Everything's about to change.

My parents returned to the States in January 2016. We'd been apart for ten and a half years. Spotting them at the airport terminal, weaving through the crowd toward them, it was surreal. My dad's hair is gray. It was black when I last saw him. To see the look on my mother's face, to see the joy, but also the pain that's been in her eyes for the past ten years, being away from her only child. I don't know. You only see that type of stuff in movies.

Since they've returned, we've raised the hotel on TripAdvisor from tenth best in Green River to second best. With their help, the skills I developed while they were gone can suddenly be used not just to stay afloat, but for progress. Actual progress. But I'm my own man now. And even though we're back together, our conversations are still mostly all about work. Nothing else. That hurts. I'm sure they want to reach out just as much as I want to, but we don't know how to talk about things after so much time apart.

Interview by Emma Starer Gross | Photographs by Kathryn Harrison

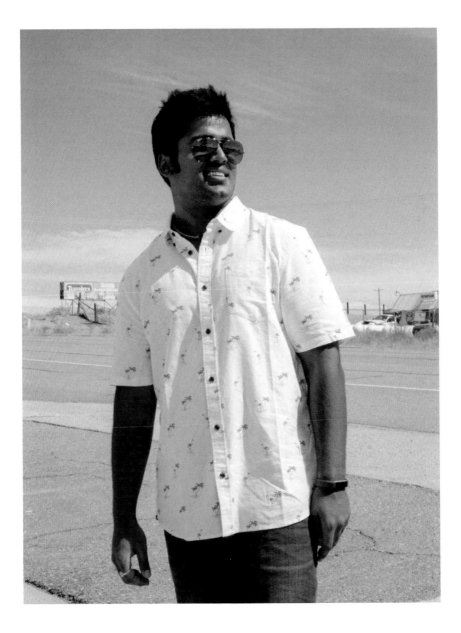

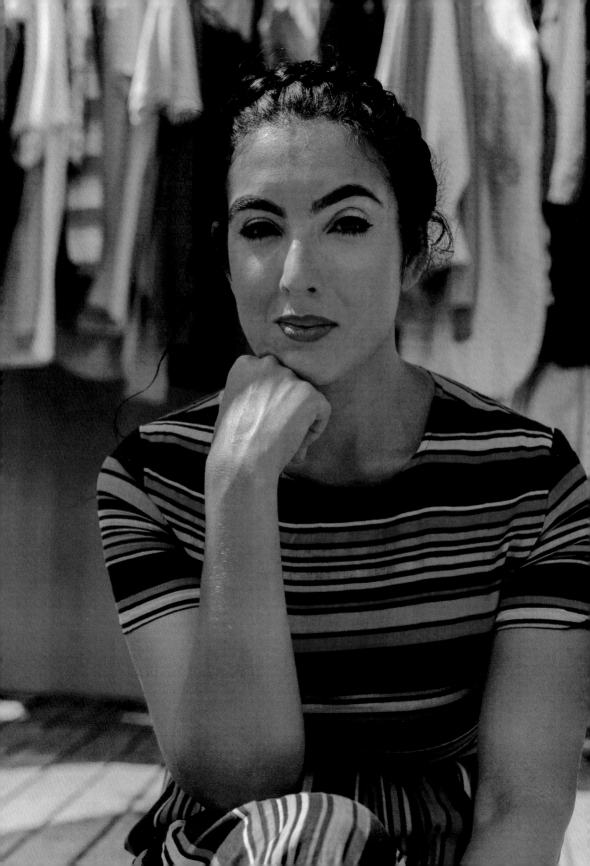

Gisele Barreto Fetterman

I grew up in the Jacarepaguá neighborhood in Rio. It's an urban area, with high-rise apartment buildings, but my family had coconut trees and sugarcane in the backyard. You can see the beach, the hills, and it's strikingly, overwhelmingly beautiful. But mixed in with those natural resources was extreme poverty and a lot of violence. Every day, we'd read in the newspaper that someone got hit with a stray bullet and died on the way home from work. Or there was a kidnapping or a carjacking.

My brother and I couldn't play outside as kids. I remember my aunt telling my mom how relieved she was that she was "only" robbed seven times in one year. I think that was around the time my mother made the decision to bring us to the United States.

I was seven when we packed our entire life into a suitcase and moved to New York. To me, America looked like a bunch of little houses that all looked the same. We lived in an apartment above a doctor's office in Queens. All our furniture, clothes, and toys came from the alley. I didn't understand why they were in the garbage. They looked perfect to me.

We would look forward to garbage day every Tuesday. Maybe the dresser someone just put out was better than the one we had, so we would trade. And it was like a game. When you have no money to buy things, dumpster diving becomes a form of entertainment. We slowly built our home this way.

About a year later, we moved to Harrison, New Jersey, a small, hard-working immigrant town near Newark. The first apartment we rented was above a Peruvian restaurant. We were one of several undocumented families in town and we got to share stories and find some comfort. But then, one by one, we watched our neighbors get dragged from their homes and deported. It gave me this immense fear of York, Pennsylvania. There was this huge prison there where people undergoing deportation proceedings would get processed, before they got shipped to Texas and then sent back to their home countries.

When I was twenty-five, I went on a yoga retreat and happened to read a magazine article about Braddock, Pennsylvania. It was a former steel town in decline. I learned that the steel that built the Brooklyn Bridge came from Braddock. I used to ride my bike over the Brooklyn Bridge while going to work or visiting friends in New York, and I was just enamored of it. It's so majestic.

I had been running my own nonprofit, working with families with extremely limited access to grocery stores, and I wanted to see if I might be able to bring my work to Braddock. It was an entire community that had been essentially discarded after the national demand for steel dropped.

So I sent a letter to an address I found online for the borough. A few weeks later, I got a call from Mayor John Fetterman. He invited me out to visit so we could talk. Two months later, I drove the 350 miles from Newark to Braddock to meet with him.

The first thing I noticed was that he was really tall—like, overwhelmingly tall. But he also seemed very kind, and there was this stoic seriousness to him. I asked him about how he got to Braddock. I'm someone who cares about cities, and he does, too. We talked a lot about development and revitalization and bringing life back to abandoned communities.

I knew right away that John was really good. I felt a goodness to him. I took that sense with me and we stayed in touch. He came to visit me in Newark a month later to see the work that I was doing firsthand. Traveling back and forth between our two cities, we fell in love.

In May 2008, I moved to Braddock to be with John and to continue my work in food justice. It didn't feel like the dark place I'd read about in articles. It was full of hope and its story was still being written. It still had residents who cared about the town, who were wonderful and deserved a second chance.

I founded the Free Store 15104, named for the zip code in Braddock, in 2012. The Free Store was a place where families could go to pick up toys, clothes, and food. It was an opportunity to take all these things that I had worked on and cared about back in Newark to serve this new community of mine. We partnered with Costco and redistributed food that was going to be thrown out.

One of the most amazing volunteers at the Free Store, Ms. Phyllis, is now almost eighty. Her mom is one hundred. They live in the same home where Ms. Phyllis was born. Ms. Phyllis saw Braddock at its apex in the '40s, when there were shops and theaters and hotels and it was the center of the steel industry in America. She had children during that time, and then over the years saw Braddock hit its bottom. She saw her neighbors become addicted to crack or lose their jobs at the mill and become homeless.

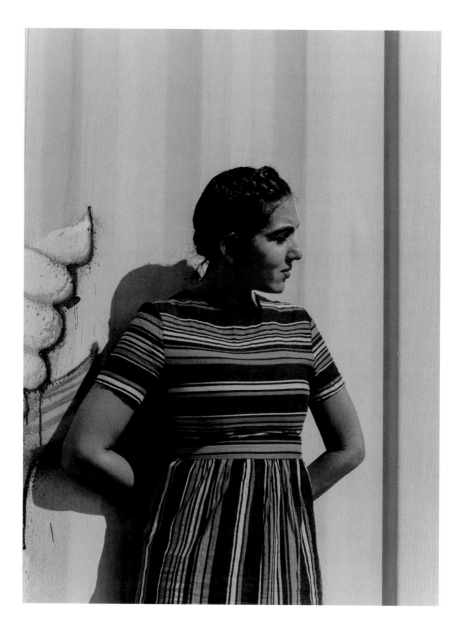

After John took office, Braddock started making headlines again, but for positive things instead of negative. In 2006, he started the largest youth employment program in Allegheny County. Its offices are housed in an abandoned church we turned into a community center. In 2013, John officiated the first same-sex wedding in the county, before it was legal in the state. The ceremony was held in our kitchen. We helped change the culture—and to show that Braddock is a place that matters.

Over the past few years, I've seen new families move to Braddock, and families that moved away have come back. To have residents excited about where they live, to see this resurgence, it's been amazing.

John wanted to do the same thing he did for Braddock for under-served communities across Pennsylvania. So, in 2017, he ran for lieutenant governor—and won. When John was sworn in, I wore a pin on my dress that said "immigrant." It was made by metalworkers in Braddock. I had one made for my mom, too. I told her, "I know I'm the first previously undocumented person in this position. But I don't want to be the last."

In April of 2018, I attended a protest at a detention center for immigrant families who have been arrested. I could see children, the same age as my children, riding bicycles behind the prison fence. It didn't feel real. I thought about how those children on bicycles could've been me. I thought about my neighbors in New Jersey who had been dragged from their homes. And I thought about the detention center I'd always been afraid of in York, Pennsylvania. It's a trauma that I'll continue to carry, because you don't just turn it off. It's still something that lives within me.

Interview by Sasha Geffen / Photographs by Ricardo Nagaoka

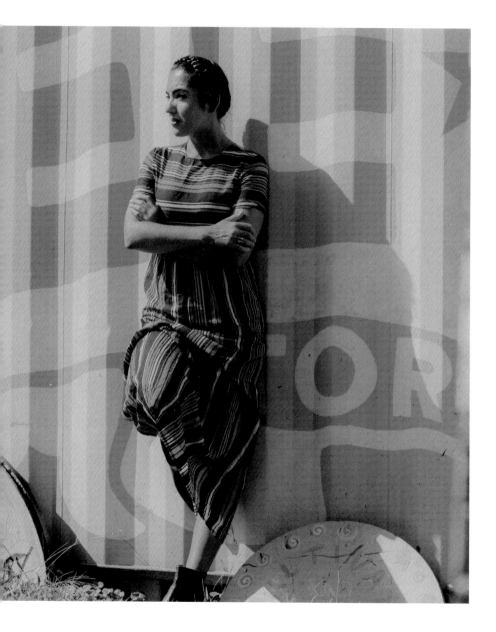

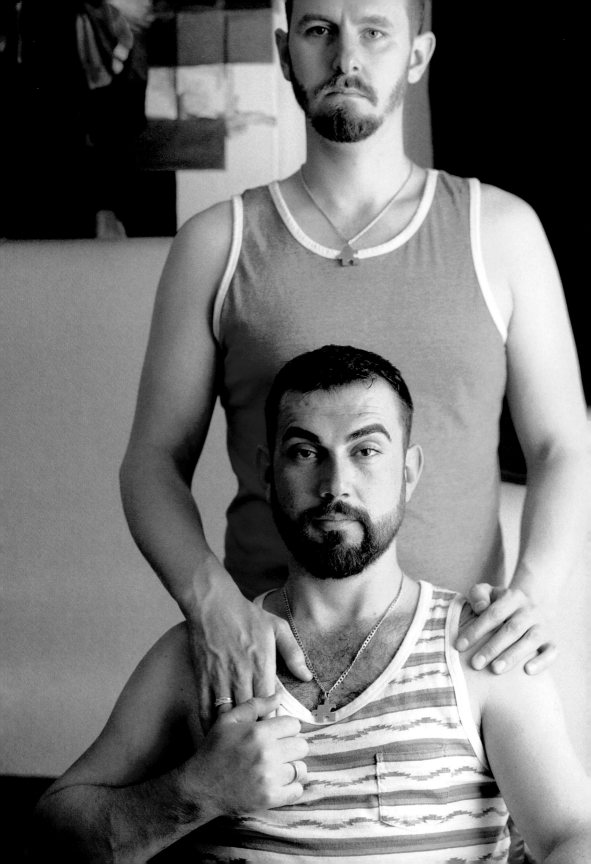

Shadi Ismail

———

It was Friday night, and my best friend, Sam, said: "I want to show you something." We ride bicycles two miles across Boise, Idaho. We come to a place called The Balcony. It is a gay bar in Boise. I don't know this. I am just new here. I don't know gay bars. There is nothing like this in Syria. We went late, around 11:00 p.m. But there is a man at the door who wants to see ID. "I don't have," I said. I wasn't speaking much English then. I look at Sam. He translates for me. Sam says to me, "How about your papers?" He means my refugee status papers. I don't have anything to prove who I am but my paperwork from Homeland Security. A 901 paper, or 109 or something. I was just coming to the United States, and this is all I have. But the bar does not know this document. So they don't want to accept it. The man says, "No, this is no good."

I was nervous. Because before, in my experience, people can be dangerous. They will kill you if they have the chance. I don't trust people. Because of what happened in Syria. I lived in a small town called Qardha. I had to leave my house after my father walked into the living room and found me kissing a man. He burned my arm and cut my hair, and said that if he ever caught me with a man again, he would kill me.

The second time, I did not let my dad cut me. I just ran away. He walked in on me with another man one day. I was on the third floor of our house. But I just ran away. I escaped through the window and jumped onto the roof of my grandfather's house and then into the woods. I slept there the first night, in the woods. Then I go to Damascus, to stay with my mother. My parents divorced when I was three and I know my father doesn't speak to my mother. I spent a year with her there. I knew my father's family must be looking for me, but in Damascus I had no problems at first. I was normal, having my life, working and everything.

I got a job at a restaurant. It was an American-style place, and the owner knew I was gay and he was very supportive. Working there it was really just me and another guy, an Iraqi named Sam. I know Sam is gay the first time I saw him, but at first we hate each other. He was acting pushy, and he is a very tiny guy, being pushy. But then we became best friends. We were together twenty-four hours every day. At work, they help me rent an apartment, and Sam lived with me. Not boyfriend, just friends. Everyone always ask us how we have so much to talk about. We talk so much about the future—where to go, what we want to do. He talked about America, and being in LGBT community, making house, all kinds of stuff. It was fun to talk to Sam, because he was extremely wise.

Then one night Sam called me and told me to not come to work again. I was scared. But I went to work to see what was going on. I saw his face was pink and his neck looked cut up. "What happened to you?" I said. He told me, "Your brother was here. They know where you work, you need to leave." They had hurt him. Sam had fought with them. He did not tell them anything. He was a hero for me. "Where am I gonna go?" I said. "I have no place to go." Sam is smart, very smart. He had already run away from Iraq because same things happened to him there. Sam told me, "Go to Jordan."

The next day we went to the government, we got passports, and I went to Jordan. I took a taxi there, to the border. I knew I could make a case with the U.N. office in Jordan for refugee status. The U.N. can't protect you in your own country, only another country. Sam knew a lot about the process. He taught me. Because he had already applied, when coming from Iraq. At the U.S. Embassy in Syria, I heard that ninety percent or maybe ninety-eight percent of people don't get approved, but the chance is better in Jordan. I was in Amman for three years waiting for my application. I worked at a shawarma place and an ice cream shop. I had my first real boyfriend there. I worked as a bartender. I walked four miles to work because I had no car. And then my application was finally approved. When I applied for asylum, they ask you to put three options. I wrote America, Canada, and America. I arrived in the United States on May 12, 2012.

I go to Boise. Sam had been approved in 2011 and went to Boise. He was there already. The caseworker asked if I know anyone here, and I say, "Yes, sir—I know Sam, and here is his address." They say it helps to go somewhere you know someone. I knew nothing about Boise but I didn't care. I was just so happy to be anywhere but Syria.

When I got to Boise, I had to go to an English-language school. I had the address downtown. I rode my bike. I followed the bus downtown, but then got lost and couldn't find the address. I spoke no English, but I saw a woman, and I said "Hi," and the lady looked at the address and grabbed my hand and walked with me across the road and showed me the door and told me good luck. This was my first impression of Boise. People are nice. And when somebody does make fun of me or make joke about being Arabic, other people stand up and say how wrong is it. A lot of people stand up for that.

Pretty soon after came that night at The Balcony. I remember I was wearing shorts. What do you call military colors? Camouflage. Dark camouflage shorts. And the bouncer was just shaking his head at my paperwork. I got the paperwork at the airport, in Jordan. It was in a bag and was sealed. They told me, "Keep it with you." The bag says U.N. on the side. But the bouncer still looks at the refugee papers. I think we cannot go in. Luckily, we have an American with us, and he knows people there. So the supervisor from The Balcony comes over, and he reads the papers, and he's like, "Yeah, he's fine. It's okay. He can come inside."

It was overwhelming. I walked in and then cannot believe what I see. The bartenders were shirtless, and music loud, and people dancing. Guys kissing guys. And a guy and a girl. It was all mixed. Crazy night. It was too much to process in my head. First time I see club like that. Let's say my mouth was open all the way. I was shocked, like, wow. We don't have this in Syria. Sam bought me a drink, and I just start watching people. Here they are having fun, and who cares? I did not dance that night, I just try to enjoy everything. People start talking to us. Sam translates. People are friendly. This was my first night at The Balcony. Later I meet my boyfriend Ian there. Now we are engaged. We will buy a house and want a kid one day. Ian makes fun of me because I like birds. My favorite morning thing is to make coffee and watch the birds. And listen to my special music, by Fairuz, a famous singer. She sings songs about me—about a boy named Shadi—but it's sad songs. It's a story of a kid who is lost, and then she finds him, and then she loses him again. Twenty years she's still waiting for him. It's sad, but people make it as fun, because my name is Shadi. In the song it says, "Where is Shadi?" And people say to me, "We find Shadi. We find him right here."

Interview by Jen Percy | Photographs by Kathryn Harrison

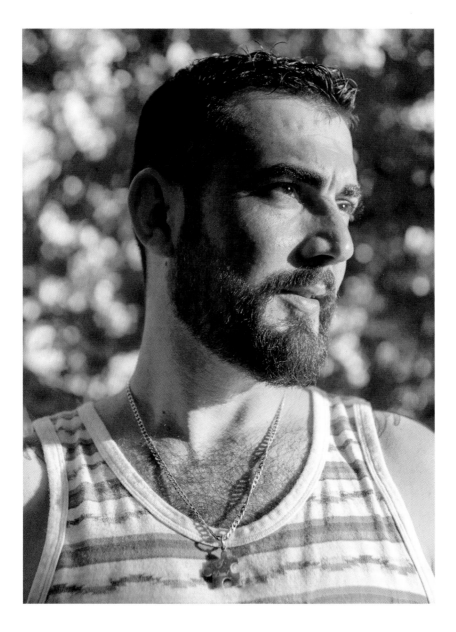

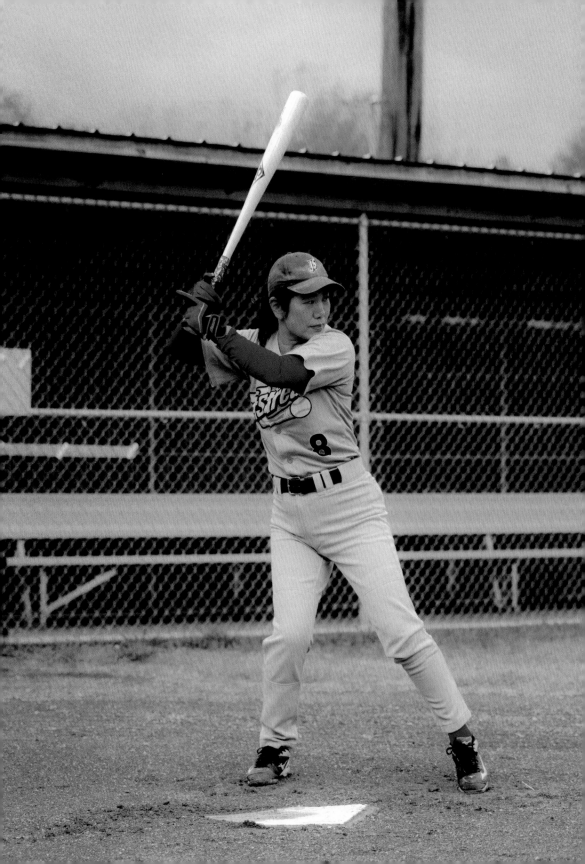

Akisa Fukuzawa

———

I grew up playing baseball with the neighborhood boys in Tokyo. When I was ten, all I wanted was a real leather baseball glove, just like the ones the Yomiuri Giants wore on TV. Instead, my mother gave me a toy glove. It was bright red. She said, "You're a girl, so this is fine for you. You'll never play baseball seriously."

My parents always had a plan for me: go to the best Japanese university, get the best job, and find a husband. But baseball is wired within me. When I was in college, I saw a Japanese TV report about American graduate programs where you learn to run a baseball team. Nothing like that existed in Japan. I thought maybe this was my purpose, to create a women's baseball team. A few years later, I decided to attend Ohio University's one-year graduate program in sports administration and management. My parents were furious. My dad stopped speaking to me. My mother told me not to gain weight.

I landed in Ohio in May 1994. I was shocked by how rural it was, how nothing in the dining hall tasted familiar except the hard-boiled eggs. I tried to keep focused on my studies. After I graduated, my professor helped me get an internship with the Colorado Silver Bullets, a professional women's team. My job was to go through fan mail and send back a prewritten thank-you letter. When the internship ended, there were no job openings. And shortly after, the Silver Bullets lost funding and had to disband.

I met Nate through campus housing. We were friends for a while and then eventually started dating. In 1998, we got married and moved to Columbus. I got a job assisting an accountant. Even though I wasn't working in baseball, I was always thinking about it. When I felt pressure from male coworkers who tried to intimidate me because I'm a woman, I put them in an imaginary batter's box and pictured myself on a mound facing them. I observed their demeanor and then determined their "strike zone." Then I figured out how to strike them out.

My parents came to visit in 2004, when I was pregnant with my son, Vincent. I had been in Ohio nearly a decade by then, and I was so excited to show them our new house. It had a basement with a couch and a ceiling-mounted projector. We turned off the lights and watched Ichiro Suzuki set a new major league record, with 262 hits in a single season.

I felt so happy, sitting there, in front of this giant, blue-and-green baseball landscape, watching this historic moment with my family. And then my mom said, "It must be nice to be Ichiro's mother and be proud of her child."

I went upstairs after that. I felt so disappointed. Everybody wants to impress their parents and make them proud and I just didn't know what my mom wanted from me. So what did it matter? A few years passed, but my relationship with my mother remained the same. Finally, when I turned forty, I thought to myself, Well, Akisa, are you going to start a women's baseball league? If you don't do it now, when?

After work, I went out and bought some balls and bats and I started posting flyers at the local bars and shops. I made a website with a short promotional video. In the video, I play every position. I play pitcher and I throw the ball. Then I cut to the catcher, and I'm the catcher. The runner was me, and the outfielder who tried to get the ball is me. Finally, I come in at home plate and say, "You know, I can't play baseball by myself, so please join me."

The first year, in 2008, there were just four of us: a Japanese woman I met at the grocery store, her Japanese friend, and her friend's Caucasian friend. We practiced throwing and hitting at the Jewish Community Center, where we rented the field every Sunday morning. I'd wake up early, while Vincent and Nate slept, and return in time to prepare them lunch. They hardly noticed I was gone.

The second year, I put an ad in a local magazine and I started getting more inquiries. By the third year, we had nine players, enough for a full team. Every weekend we played from 10:00 a.m. until lunchtime. We called ourselves the Columbus JetStream.

The players were young or middle-aged working moms, like me. I think that each had a reason for being there. There was a woman who'd had a miscarriage and was now going through a divorce. Another who was recovering from a serious illness. I remember packing up one day after a game and one of my teammates said, "That was just what I needed."

Before long, we had enough players to form a second team. This one was called the East Side Pride. We wore maroon uniforms and Columbus JetStream wore baby blue ones. We played against each other every weekend of the summer, until fall came and the frost made it hard to catch a baseball.

By our fifth year, we had become local celebrities. We were featured on *Good Day Columbus* and we marched in the Fourth of July parade. I wore a princess crown and a sash that said "Miss Baseball." We went to New York City and competed in a game at Central Park. I'd never been there before. We were even guests on a Japanese morning show, and after that, a major Japanese newspaper asked me to interview Hideo Nomo, the pitcher who moved from Japan to play for the Los Angeles Dodgers.

But over time, some of the players in my league moved away. Others became busy with work or children. Women change. Our bodies change. Our goals change. When women do everything, it's hard to make time for baseball. By 2016, there were just three of us again. I thought, Okay, we can find new players, we can build this back up again. But then, one of the women came to me and said, "Akisa, I'm leaving, too."

I cried. I didn't want it to end. Everybody asked me, "What are you going to do now?" I told them I wasn't sure. I didn't know anymore about my purpose in life. When the league failed, I worried it would prevent other women from forming their own leagues. Women aren't often given second chances.

"You're too old anyway for baseball," my mother said over the phone. "I don't care," I told her. "I'm going to keep playing."

Last year, I signed up for the Columbus Clippers, which is the minor league fantasy camp for the Cleveland Indians. All the players were men, and I was the only woman. But I did okay. I had a couple of hits, and I had a great time. The organizer recruited me to play again this year, and guess what? A few other women signed up, too. They must've thought, Well, if Akisa is playing, then we can play, too.

My entire life I'd been wondering about my purpose. I'm not the fastest. I'm not the strongest. I'm not the most talented. I started a women's league that no longer exists. But knowing that I encouraged other women to play baseball makes me very happy. If you're a woman and you've thought about playing baseball or you loved playing as a kid, then you should do it. If you don't have a team, make one. Make your own team, for God's sake.

Interview by Emma Starer Gross | Photographs by Ricardo Nagaoka

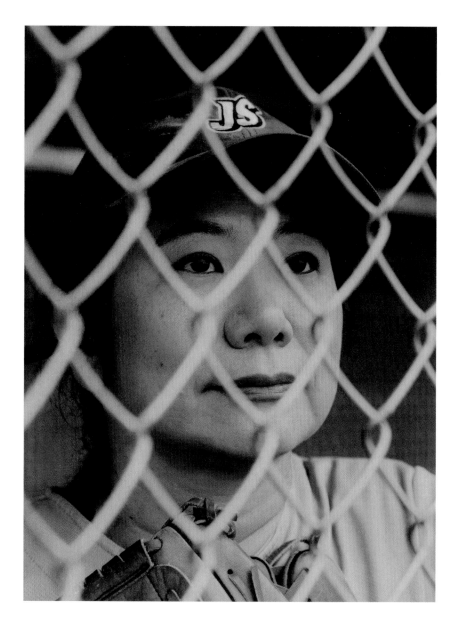

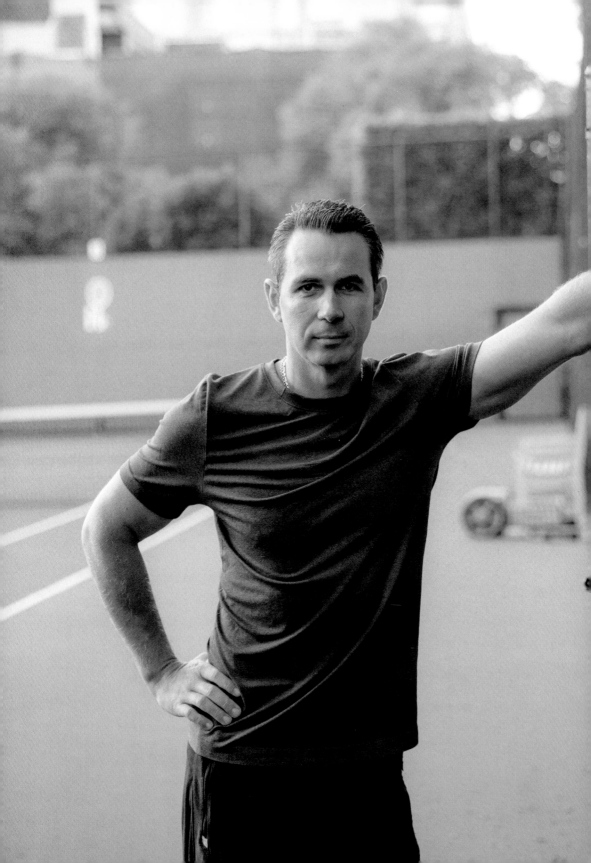

Marian Banovsky

———

It happened in September 2006, when I was twenty-three years old. I had spent the summer working at a golf club in North Carolina with my best friend, plus his girlfriend, plus his friend who was very tall and often going to the gym. The four of us were on the same flight home to Slovakia, with a twenty-hour layover in New York. All my life, when I pictured America, I pictured New York City. And now I was going to be there.

It was 6:00 p.m. when we landed. My friends wanted to sleep at the airport and wait for our connecting flight. But I had been waiting the entire summer for this layover. So I convinced them to come with me, just for a little while.

We started at Ground Zero around dusk and then walked to the water to see the Statue of Liberty. From there, we took the Broadway street all the way through Manhattan. My friends were dragging their feet, but I was in awe. I was looking around like, "What is that building? What is that building?" Everywhere were lights and noise, with cars going on and this and that. And the people! The people were never-ending! I couldn't understand what anyone was saying, but it didn't matter. I was in this alternate universe where everything was beautiful.

Around midnight, my friends wanted to go back to the airport. They were tired, but I was like, I don't care about being tired. We went to McDonald's and they fell asleep with their heads on the table. I ordered a coffee and went out into Times Square. For hours, I walked back and forth with my head tilted back, taking pictures, making videos.

At dawn, I went back to McDonald's and woke up my friends to go to Central Park. They wanted to go to the airport, but I take them to Columbus Circle and to the Empire State Building. If you've never been there, I really recommend it. There is so much shopping! I buy chain necklaces; one for my mother, one for myself.

Around noon we go to the airport, and I have to admit I am exhausted. I have been awake for twenty-four hours and I'm ready to sleep on the plane. But then, I open my backpack. I open my luggage. I take everything out, I put everything back. My passport is gone.

My mind starts to have tons of questions: What do I do? Where do I go? My friends' English is a lot better than mine, so I ask, "Can one of you stay with me?" They look at each other and they say, "Sorry, no." I turn to my best friend. We've known each other for years. We even shared a room in college. I say, "Can you stay with me?" And he says, "Sorry, no."

To be nice, they give me their phones because mine doesn't have data. Then they pick up their bags and go through security and I am all alone. I have two duffel bags and a backpack and three phones and little English.

I tried to be optimistic. I said, Okay, I will go in a taxi to the embassy. I will get a replacement passport and return to the JFK and then get on another flight. So I get in a taxi and I say, "Embassy of Slovakia," and the driver has no idea. I am not expecting this. But luckily he has his books with addresses for the whole city and he pulls over and we turn the pages until we find it. But when we arrive, the whole area is closed off because the United Nations is having an international meeting, so he drops me off on the corner.

I am very tired. I haven't eaten. My three bags together are sixty pounds with no wheels. I decide to leave them on the street and walk around to find the embassy. I take a couple steps and suddenly there are ten or twenty police officers around me yelling, "Do you have a knife with you? Do you have a firearm with you?" And my English isn't good, so at first I say, "No." And then I say, "I don't have a knife on me, but it is in my bag." I always carry a knife when I go out for hiking.

They ask again, "Do you have a firearm?" I say "No," but then I say yes, "I have fire because I have a lighter in my bag." They are not happy with this. The security men hold their guns at me. They search my bags, and the one who acts like the boss, even though he is a very small man, becomes red and yells, "He has three phones!" And that's when the FBI arrived.

I am with the FBI for two hours trying to explain how I lost my passport and these are phones from my friends. Finally an FBI agent says, "We checked him. He's okay." They point me to the embassy. It's just across the street.

I go to the embassy and hear people speaking in Slovakian and feel relief. But then a man says, "Come back tomorrow. We're closed." I tell him please, I need a place to stay. He says there is a pay phone outside.

I call the head of my work-for-hire program and tell him I need a place to stay. He does a quick Google and gives me an address. I walk through the streets. My arm and neck are bruised from the straps of my luggage. I think about my friends who were with me here on Broadway just the night before. I think about the photos I took when I thought the buildings were beautiful and the people I couldn't understand were exciting. Finally, I arrive at the street of the hotel, but the address does not exist. I ask in a liquor store and the man says "No hotel on this street, sonny."

After that I sit down on the sidewalk because I cannot walk any farther. I think of my parents waiting for me at the airport. I think of the North Carolina T-shirt and the whiskey I wanted to give my father. I think of the necklace for my mother. And then I hear someone call to me. It's a man in a black suit who is attending to this parking lot. He walks over and asks if I am okay. I show him the address of the hotel, but he doesn't know it. He says, "I know somewhere else. Just a couple blocks away. Don't worry."

He picks up my bags and walks with me to the street corner and hails a taxi. He tells the driver the address and helps me put my bags in the car. I thank him and get in and I think, Wow, sometimes you meet an angel on your way as you go.

We arrive and the hotel is a YMCA. I only know YMCA as exercise place, but it turns out they also have beds. The man behind the counter says, "We can't give you a room. You have to book twenty-four hours in advance." I beg him. I say, "Please, is there any way?" And he says, "Those are the rules."

Then I say, "Sir, I lost my passport this morning and then I put down my luggage and the FBI came and the embassy is closed and I've been up for many hours. My head is so heavy it cannot hold information and my body is so sore it cannot stand up straight. I need your help."

The man walks away. He returns and takes me to a small room that is the most beautiful small room I could ever imagine. I lie down on the bed and fall asleep.

The next morning I go to the embassy. Waiting in line, I meet people from home. There is a businesswoman who has lived in the U.S. over thirty years. She gives me her card in case I ever need help. There is a man who is also waiting for a new passport. We grab a beer and he tells me about his life in the States. He likes America. He says the people are mostly nice. I agree with him.

When I get back to my country, I give my family their gifts. My mom likes her necklace and my dad likes his whiskey and North Carolina T-shirt. I return to university in the fall, and one day I open my binder, and from one of the plastic pages slides my passport. This is impossible, I think. But of course it wasn't. I'd had my passport in my bag all along. At the time I just didn't see it.

I moved to the U.S. for job opportunities in 2013. I am a personal trainer, and I heard people in California care very much about fitness. On the side, I drive Uber. I keep small bottles of water in the door if people get thirsty. I help when they have bags. And I look up directions if they ever need a hotel, but these days, it's pretty easy for them to do a quick Google. I hear a lot of stories from passengers. I like to hear them and I like to tell them mine. Because stories are things you never lose.

Interview by Emma Starer Gross | Photographs by Nailah Howze

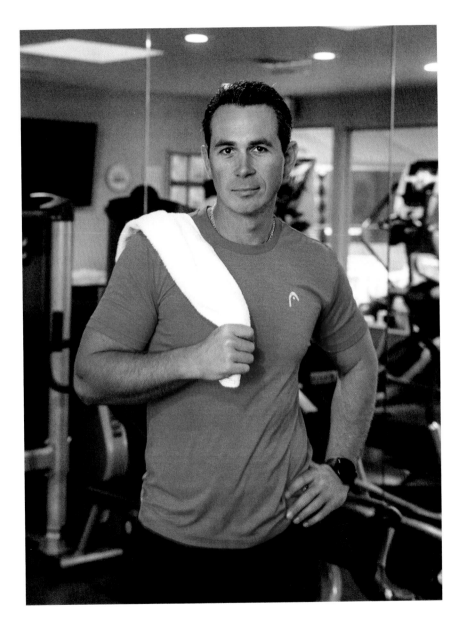

Milad Yousufi

———

I was born in 1995, during the darkest days of the civil war in Afghanistan. There was no electricity, and the only means of transportation my parents had was a bicycle. The night my mother went into labor, my father had to balance her on his lap and bike to the hospital. The way he tells it, they had to stop to fight off a pack of rabid street dogs with a piece of steel pipe every few hundred yards. He says that five-mile bike ride took two hours. Afterward, my parents had to wait for a lull in the gunfire before they returned home with me in their arms.

When I was growing up, music was forbidden by the Taliban. If you were caught listening to music they would cut off your ears, and if you were caught playing it they would cut off your hands. But my family was full of musicians. When I was a toddler, my uncles showed me pictures of their old pianos and I started drawing piano keys on paper and pretending to play them. I loved it when my uncles walked through the house singing, their voices echoing through the halls. Fortunately, our neighbors never reported them.

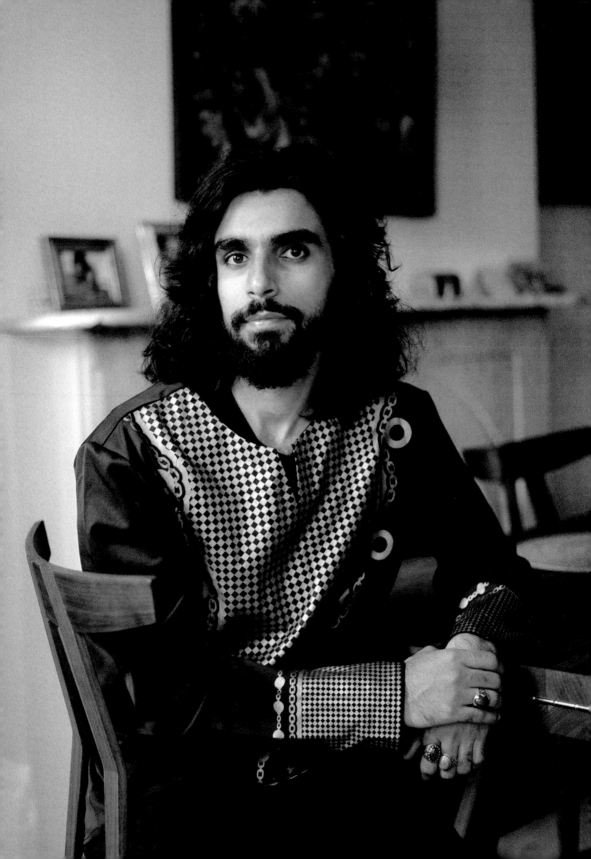

When I was fifteen, nine years after the Taliban fell, a music school opened in Kabul and I saw my first real piano. There was only one piano for all fifty students, but I still found the time to practice every day for hours and hours. One of the first songs I learned to play was "Für Elise," which I'd heard playing from an ice cream truck that drove around our neighborhood. Pretty soon, I was practicing so much to make up for lost time that I started to develop tendinitis!

All this time, I'd never had access to my own piano. So when I learned about an old Russian piano for sale for two hundred dollars, I couldn't believe it. It was probably one of just a few pianos left in the whole country after the Taliban started confiscating and burning musical instruments. There was just one problem: Its owner had buried the piano in his backyard to hide it, and when he dug it up, it was totally beat-up, with spiders and mice living inside.

But I didn't care. To me, that piano was the most beautiful thing in the world. I went with my dad and my brother to pick up the piano twenty miles away, and when we got home, it took thirteen people almost an hour to carry it up the stairs to our third-floor apartment. Everyone in the neighborhood was so excited. Most of them had never seen a musical instrument before.

There were only two piano technicians in all of Afghanistan, and one of them agreed to fix this piano. After I finally got it to play in tune, I was practicing for eight hours every day. That was a magical time. Over the next few years, I traveled all over the world to represent Afghanistan in international competitions. I went to New York and Boston and all around Europe, where I played and conducted in some of the world's greatest concert halls.

In 2015, I was invited to a music camp in East Hampton, New York, along with my friend Fayez. It was a wonderful program where they invite people from all over the world for master classes. All day, we played music together and exchanged ideas and hung out at the beach or by the pool. It was very luxurious.

Even so, I couldn't believe some of the things my friends would complain about—like the Wi-Fi speed! That's when I realized that no matter how blessed human beings are, they'll always ask for more. I just felt lucky to have 24-7 electricity.

One night, we were coming back from playing soccer and we saw dozens of people crowding into a bar, taking pictures of someone. We peeked in and I said, "Who is that guy?" My friends told me it was Paul McCartney. I was twenty years old, but I had no idea who he was. Now I know he is very famous.

Then, on our last day of camp, when Fayez and I were supposed to fly back to Afghanistan, there was a bombing at the Kabul airport. I called my mother and she told me I couldn't come home. She said, "It would be better to stay on the streets in New York and live than come home and die." I had nowhere to go. I had only my backpack and a couple hundred dollars in my pocket. I felt totally numb.

I reached out to the only person I knew in New York, a woman I met when I came here two years earlier to play with the Afghan Youth Orchestra. Luckily, she was willing to host me and Fayez at her house. After that, an immigration aid group helped us move to Queens. My bag was mostly full of formal concert clothes for conducting—my tuxedo, some bow ties, my black suit and just a few casual clothes. I didn't have money to buy anything else. Everywhere I went, I was overdressed.

Fayez and I both worked the night shift at a Popeyes. It was in a very dangerous neighborhood, and people were always coming in drunk. We faced a lot of Islamophobia. People stared at us constantly, and one time someone even chased Fayez down the street with an iron rod.

I hoped and prayed that one day we wouldn't have to work there. But we both had to send money home to our families. My father had passed away from a brain tumor before I left home, so it was up to me and my brother to support my mother. I was working so much that I began to lose hope I would ever play music again.

I tried to relish the small moments of joy. Like when the biscuits came out of the oven, we had to put butter on them with a brush. I would hold the brush like a painting brush because I am also a painter. Everyone would look at me like, "No, you have to hold it differently so you can hold more butter in your brush." But I kept doing it my way, because it made me happy. Then one day this customer looked me in the eye and said, "You are not made to work here." I don't know why he said that as if he knew me, but it always stuck with me.

After ten months at Popeyes, I was invited to audition for The New School, which has one of the best conservatory programs in the world. I hadn't touched a piano in a year. I was so nervous. As I played, my hands felt frozen and my body was stiff. Still, they offered me a full scholarship. My teachers helped find me a free place to live and finally I was able to leave my job at Popeyes.

Every day the situation in Afghanistan became more and more dangerous, so I decided to apply for asylum. I felt abandoned by my home, and yet I longed to go back to it. To this day, I write songs to express both the sorrow of my loss and the thousand beautiful memories I keep with me from Kabul. I hope one day I can reunite with my family and try to somehow heal the pain we have.

Recently, after a recital, one of my instructors told me she had a surprise for me. She took me to this big, fancy house in Park Slope. Then she said, "Look upstairs." I went up to find a Steinway Model A from 1903. Someone had heard about me through The New School and decided to donate their family's piano, all the way from California. It's the first piano that's been mine since the one I bought for two hundred dollars in Afghanistan. I ended up selling that one so I could buy my mom an LED TV to cheer her up after my dad died. It felt like losing a part of my soul.

In February, I was commissioned to write a piece that premiered at Carnegie Hall. I felt happiness and sadness together. Happiness because it's such a privilege to hear your piece as a composer in one of the world's greatest concert halls. Sadness because I wish my friends and family were with me for this wonderful event.

All the greatest times in my life have always been coupled with the saddest times. So many of the people I grew up with have been killed, and I can't even go back there to see their empty places. I feel all the time that I'm stuck here. It's like if you were to buy a golden cage for a bird. It might be a really beautiful cage, but it's still a cage.

Interview by Julia Black | Photographs by Valerie Chiang

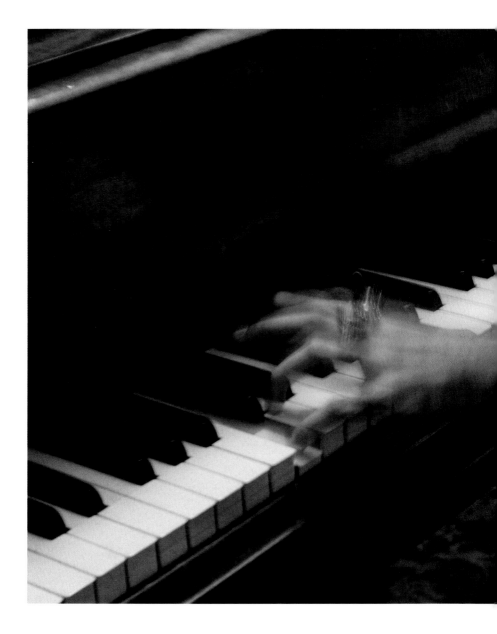

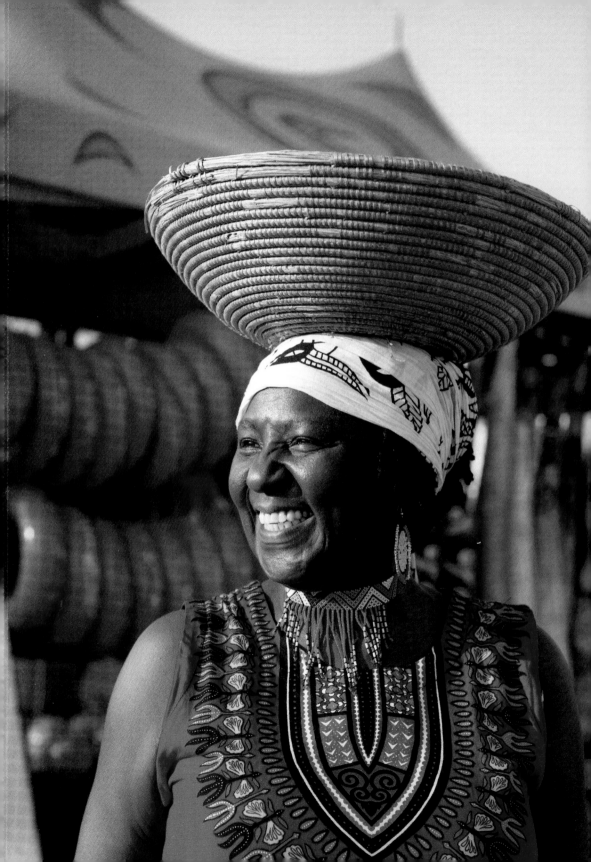

Elizabeth Kizito

———

Our lives revolved around the banana tree. Mostly we ate bananas—bananas steamed in banana leaves or made into a porridge. The women had babies in the banana garden, so that's where I was born—on a banana leaf, under a banana tree. Maybe once a year, I would get a bottle of Coca-Cola, and it would take me two hours to drink that soda. I wanted it to last forever. We had very few sweets, in fact—sometimes hard candies, or sugarcane, or mangoes, but that's it. I was always craving candy. I thought, When I grow up, I'm going to eat all the things I like.

I was seventeen when I tried a chocolate chip cookie for the first time. It was 1972. One of my teachers in Uganda helped me come to America. She found me a host family in Denver, Colorado. They were a very excellent family: a husband and wife who were both schoolteachers. One Christmas, the lady baked chocolate chip cookies. She told me to come to the kitchen to try them, and I could not believe it! They were hot and fresh and so good. I liked them too much. The lady had to make some more because I couldn't stop. At that moment I decided, I have to make some cookies so I can eat as many as I can get my hands on.

So I taught myself. I got a recipe from *Good Housekeeping*. I made just enough for myself—however many cookies you can make from one bag of chocolate chips. Six years later, I met a man in Denver, we got married, and I started making cookies for him, too. Together, we moved to his hometown, Louisville, Kentucky, where we had a baby in 1983. Then we divorced.

I was newly single and trying to make enough money to support my baby boy. I waited tables at a restaurant called People's Place on Bardstown Road. During my time off I baked cookies, and I took them to work to share with my coworkers. "Why don't you bring some more the next day?" they said. "We'll buy them from you." So I did, and I made a little profit. I started selling more cookies, week after week. My coworkers would say, "Elizabeth, go make some fabulous cookies." I wondered if I could sell cookies on the street and make more money than I did from waiting tables.

At the restaurant, I met my current husband, Todd. He was a cook there. He suggested that I make some other cookies. That's when I started making oatmeal raisin. And later someone said, "Have you heard of snickerdoodles?"

I started selling my cookies door-to-door. Different buildings on different days. Sometimes when I couldn't find daycare for my son, I'd bring him along, too, walking all day with a baby on my hip. Soon I decided to do this full-time. You know, in Africa, they do most of their vending on the street. And everything is harder there, so I knew I could do it here. And sometimes it was hard. When I went to the permits and licenses bureau, they asked me what I wanted to sell. I said, "Cookies," and they laughed at me. "You don't have a hot dog stand, you don't have a taco stand. You're just going to sell cookies?" They rolled their eyes. I was going to show them how it was done.

My tiny apartment became a factory. On baking days, it was as hot as the oven all day long and I cracked eggs and mixed dough and slid tray after tray of cookies into my oven. I lived in a forested part of the city, and squirrels loved to sneak in for a snack. I became tired of hearing them gnawing on my walls, so I soaked my entire door in Tabasco sauce to keep them out. Todd thought I was crazy. "Maybe it's time to find somewhere else to bake?" he said. So I began to use the kitchen at a local pizza parlor. I'd arrive as they were closing up, and all the barflies and drunks would still be there. They loved to talk to me; there was always some guy who'd offer me advice or say he knew where to get some piece of equipment—one time a guy helped me get my vending cart. I'd bring my son along, too, and he'd sleep quietly in the corner on a pallet, or wherever we could find some room.

It was my husband who had the idea that I should carry the cookies on my head, like we did in Africa. One day I was dancing in our house with my basket on my head. It dawned on him: "Whoa, that's what you need to do to be famous. We need to put a basket on your head and go out there and sell those cookies. Everybody will know you." It was true: instant success! I think people had seen women carrying things on their heads in *National Geographic* or on TV, but they'd never seen it in real life. "Who is she?" people asked. "What are you doing?" Sometimes I'd wear a traditional Ugandan outfit, too, with African jewelry. Everybody would honk at me all the time, everywhere I went.

You know, when you come to America from Africa, your family wants you to be doing something really big, like working at a bank, or being a nurse—something very professional, something they can tell their friends about. But selling stuff on the street? My mom was not happy about this. In Africa the people who do this type of work are the lowest—they are the women who have no money. When she heard I was doing this in America, she was so embarrassed she didn't tell anyone.

My mom came and visited me in Louisville in 1989. She was surprised by how many people knew me. I had become famous by then. I'd go to the mayor's office and all the girls there would stop whatever they were doing and say, "Cookie lady's in the building!" She'd go with me to the ballpark or to the flea market, where I sold cookies, and people went up to her and congratulated her for being my mother. When she saw my success up close, she changed her mind about me. She said, "Oh god, you work so hard, I didn't realize that. Everything's great." Once I left her to man my booth at the market, even though she didn't speak any English. People came up to her and asked, "Do you know where the bathroom is?" But she didn't know what they were saying, so she'd tell them, "Chocolate chip, snickerdoodle, peanut butter." She had a great time. She didn't know where the bathroom was, but she knew how to sell cookies.

She told me I needed a real bakery, a place people could come to buy my cookies. I told her we didn't have money to get a place, but she insisted. She took me for a walk in the neighborhood and found a place that was for lease. She said, "You have to get a place like this. You have to do whatever it takes." I didn't think I could do it, but we got together the money and the business took off from there. She was a wise lady.

The mayor of Louisville was one of my regular customers, and he arranged to present Mama with a key to the city. She was so honored. It became her prized possession. She pulled it out every time we went to the embassy for a visa. She would hand it to officials and I could see the pride in her face. She understood that my hard work was recognized here by important people.

Interview by Natalie So / Photographs by Kathryn Harrison

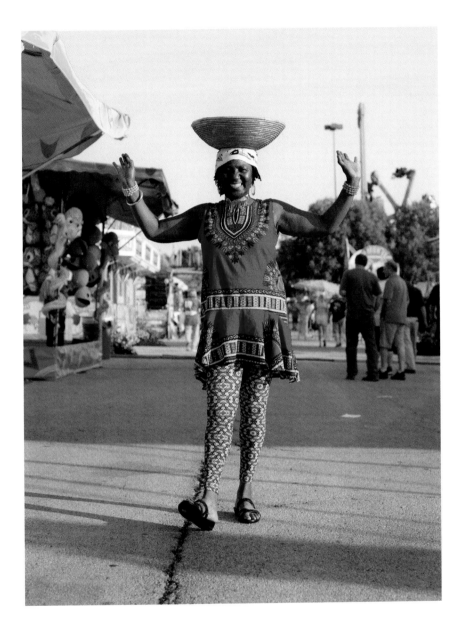

Victoria Spector

———

I came to Chicago with my mom, my eighty-one-year-old grandma, and my older sister and her family. I was nineteen. It was the winter of 1980 and we stayed in Rogers Park with some of my sister's friends. It was snowy and cold and we didn't have good clothes to wear or money to go anywhere, so for the first few days I never left the neighborhood. Coming from Kiev, a very old city, with very old architecture, monasteries, old churches, and beautiful landscapes, I thought America would be all skyscrapers and beautiful people and shiny cars. But Rogers Park was none of that. Oh my goodness, I wanted to cry.

One night, the family that sponsored my family's immigration invited me to a Russian nightclub near where we lived. It was this big banquet hall with red velvet drapes and gold picture frames on the wall—they were probably from estate sales or back alleys—and hundreds of Russian people drinking and eating and dancing and sometimes fighting. Everyone looked so fancy and there was live music and everything. I couldn't believe it. It felt exactly like the nightclubs I used to go to on special occasions back home.

Nightclubs were a hangout place in the Soviet Union because our living conditions were so cramped—six people to one room. There were no restaurants, except for maybe little cafeterias at work. So we would bring food from home to these nightclubs and celebrate. We always celebrated, whether it was for an anniversary or a birthday. When you live in suppressed conditions and there's an excuse to have a good time, you have to celebrate it. In Chicago, though, Russian immigrants went to nightclubs for everything—for advice, for a good time, for connecting, reconnecting, for having odd experiences. People did business there. They would marry their children there. It was a melting pot for entrepreneurs, for drug dealers, for people looking for love.

And the nightclubs weren't cheap: The price per plate was sixty dollars. We would order caviar and blini and deli cold cuts and a special Russian salad called olivier. And usually there would be some kind of hot dish that only the chef at that nightclub knew how to cook. It was all just a big show because none of us had any money. At the tables, the conversation was, "Oh, I found this outlet store where you can buy a twenty-five-cent loaf of bread," or, "I found this cream cheese on sale that was sixty-nine cents." Everyone was so poor that we were basically eating Ball Park hot dogs on Wonder Bread with cream cheese at home. Luckily, the men paid for everything.

I started going to nightclubs about once every month, and each time, I'd get dressed up and dine lavishly. Then, in the mornings, I'd have to wake up and go back to reality. I worked as a merchandise receiver in the basement of Goldblatt department store downtown. I was making $3.10 an hour. I had to take three types of transportation to get there and all day I would open boxes and take out clothes. Then on my break I would go to all the departments and look at the fashion displays. I had been certified in garment construction in Kiev, and my grandmother was a seamstress, too, so I'd been around garments my whole life.

My friends and I were very aware of fashion and concerned with how we looked. Before we went out to nightclubs, we'd put on clothes we bought off the sale rack in the basement of Marshall Field's and then we'd ask each other, "Do my panty lines show?" or "How is my bra strap?" We'd put on makeup together and pluck each other's facial hair. I even shaved my legs one time and I still have scars from it because I had never used a razor before! We were very intimate with each other because in the Soviet Union, everybody lived in close proximity. You just got used to sharing everything.

I would try to look pretty to meet somebody at these clubs, but of course, I ended up falling in love with a guy I'd known all along. Igor was the cousin of the family we stayed with in Rogers Park. Back then, there was a network of Russian families helping other refugees get sponsorship in the United States, and Igor owned a car, so he would drive to the airport to greet new refugees as they arrived. He claims he saw me there the day I landed, but I don't remember that. All I know is we became best friends and he took me under his wing and introduced me to friends that we still have today.

I didn't think he was my type at first, but about a year into our friend-ship, Igor purchased tickets for us to see a Beatles tribute band. He'd had an ulcer that started to bleed, and he did not take care of it or tell anyone about it because he wanted to take me out. But right after the concert, he got out of the car and just fell on the pavement. He went to the hospital and found out he had been bleeding for seven days! A week after that, we were sitting in the park and we kissed, and that was that. We got married in 1984 and had a son, Arthur, soon after.

I bought my first sewing machine with the money we got as a wedding gift. By that time, I'd been working as a designer's assistant for Alice Padrul, long before she had her own bridal line. After a while, I realized I wanted to be making my own designs, and not just overseeing them for somebody else. In 1986, I launched my own label: Victoria March, which is short for my maiden name, Marchenko. I made designer sportswear—loose-fit, drapey jersey garments.

I was very ambitious about this business, so when Igor's mom offered me her basement to work out of, we decided to move in with her. That's how we all got stuck in suburbia, which I did not like. We had another son, Dylan, and over the years, we still went out to nightclubs. They had evolved, too: The decorations were toned down, and there were no more gold frames on the walls or red drapes at the entrances. They became more modern as the immigrants who owned them began to adapt to a new culture.

When Igor's dad turned sixty, we held the party at a Russian nightclub. We did the same thing when my grandma turned ninety. The nightclubs were almost like an extended living room, where our whole family could get together and order as much as we wanted and be as loud as we wanted.

Igor and I celebrated our tenth wedding anniversary at a nightclub in a basement in a very bad part of the city close to O'Hare airport. Recently, Arthur told me he remembers falling asleep that night on a pile of coats under a banquet table. And I thought to myself, why did we have a pile of coats under the table? Here we were, these successful businesspeople, paying sixty dollars per plate, and still, we would not pay one dollar to give our coats to an attendant at the coatrack? Some things never change.

Interview by Jennifer Swann | Photographs by Oriana Koren

Aileen Hill

———

When I was three years old, my dad took me up to the top of a mountain in Oahu and said, "Tomorrow, your ojisan takes you. You are going to be like his daughter." It was New Year's Eve 1948 and there were fireworks in the distance. My dad was not normally very emotional, but he was crying and I couldn't understand why.

From that moment on, I didn't ask my parents' permission for anything. If I wanted to do something, I asked my grandfather. But he didn't allow me to do a lot. I was only allowed to play outside for one hour a day because he thought playing was a waste of time. He gave me a watch and said, "It's your responsibility from the time you walk out the door to the time you walk back to know when an hour has passed, and if you don't live up to your responsibility then tomorrow you lose your playtime." It was as simple as that. When I'd complain that everybody else was still out playing, he'd say, "That's okay. When they grow up, they won't know how to do anything. They'll have nothing."

We lived in a valley, with mountains on both sides. There were mango trees and papaya trees and banana trees all around. Back then, you could catch one bus and stay on it around the entire island. We would bring books and pick mountain apples and he would tell me about old Hawaii, when he first came out here and worked in a pineapple field. He'd point out all the different beaches and show me where the crabs were plentiful. He even took me to this cliff to fish, but he told me I would never be a fisherman. He said, "To be a fisherman, you have to be silent. And you're talking all the time."

When I started school, I did not speak English, and my grandfather figured that in order for me to get along I needed to learn it. But he also said, "You need to learn to keep your culture." So every day, I went to English school and then came home, dropped my books off, and went to a Japanese school. He pushed me to speak up in class because he said if you don't speak up when you want to know something, then you don't deserve to know it. He said the expectation of most of the teachers was that a Japanese girl would not be aggressive, but that's not the kind of girl he was raising.

Hawaii was not part of the United States yet, and I didn't have any sense of whether I was American or Japanese. I just straddled that line. My grandfather and I walked to the library every weekend and picked up books in both languages. He used to say that anything can be learned out of a book, so why attempt to do something and waste your time when some-body's already tried it? We would get the Japanese newspaper and the American newspaper, and he would tell me to look at one and find the same article in the other and then translate them both. He wanted me to notice the difference in reporting.

When I was seven, my grandfather decided to tell me about "the ghosts in the closet." He told me that as a young man he was not a good person, that he drank a lot. He told me that my uncle is an abuser. And he told me that my mother was not quite right and that he didn't want me staying alone with her. One time I asked him why he'd chosen me to tell these things, and he said, "A man's worth is measured by the people he leaves behind, and you're my last hope."

My grandfather was killed in a car accident when I was twelve. He was crossing Kamehameha Highway when he was hit by a Navy vehicle. He was in a black suit, carrying white flowers, on his way to somebody's wake. I remember a Navy officer came in to talk with my parents and the family about not pressing charges against the guy that killed him. And I stood there and watched my family back down because they were afraid. This was right after World War II, and Japanese people didn't fight authority. They just didn't.

After my grandfather died, my life came to a screeching halt. I decided there was nobody that was going to tell me what to do and that I was never going to speak Japanese again. I was angry with everyone. I went back to live with my parents and I learned that I could push my dad's buttons by saying, "You gave me away. You can't tell me what to do." But my dad was out of town a lot, and I soon realized why my grandfather said those things about my mother. It made me wonder if he was arming me with knowledge to be able to fight her.

One day, I came home from school, and my mother had this bonfire going in the yard. She said, "I burned all your stuff." I went berserk. I might have said or done something that she didn't like the night before, I really don't remember, but she burned all of my grandpa's belongings—he liked these really loose pajamas that I'd sew for him and I used to wear them after he died—and she burned all of my pictures of him. She burned everything.

Sometimes she'd wake up and she'd be fine, and the next day she'd wake up and things were not so fine. I had a friend that lived across the valley and we would see each other from our front porches and I'd signal to her with flags depending on what mood my mother was in. If I put a red flag out, she knew that she shouldn't come over. And if I put a white flag out, that meant that she could come over if she wanted to.

For many years, I was never sure why my grandfather chose to raise me, or why he eventually told me some of the things he did about our family. It didn't make sense. Looking back, my mother must have done something that concerned the family enough to have her father step in and take care of me. But at the time, he told me it was tradition for an old person to take a grandchild—that it keeps the old people young. And I believed him.

I'm seventy-four now and I live in North Carolina with my husband. I have three grandchildren and my youngest, Olivia, lives with me. I told my daughter I think I've mellowed out a lot from when I raised her, and she said, "Mom, you wouldn't let me get away with what you're letting Olivia get away with now." And I said, "Well, it's different with a grandchild because with a grandchild, you can give them back to their parents." And then I thought, Well, maybe the reason my grandfather was so strict was because he couldn't give me back to my parents.

I don't have anything of my grandfather's anymore, but he's still with me. I hear him in my head when I talk to Olivia. When she goes out to play, I give her a watch and I say, "If you come home late, then tomorrow I'll subtract those minutes from your playtime." I think he'd be proud.

Interview by Gina Mei | Photographs by Valerie Chiang

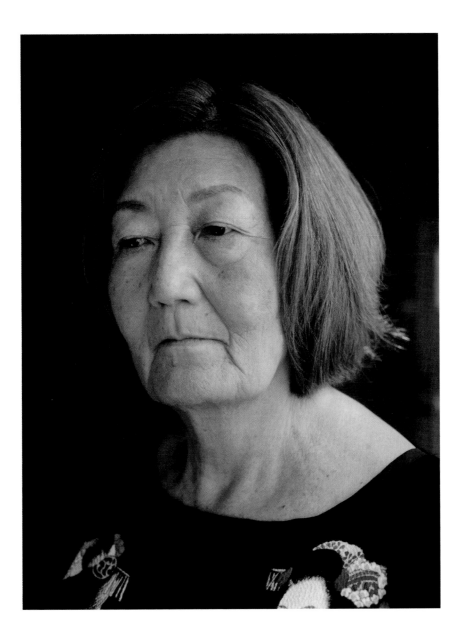

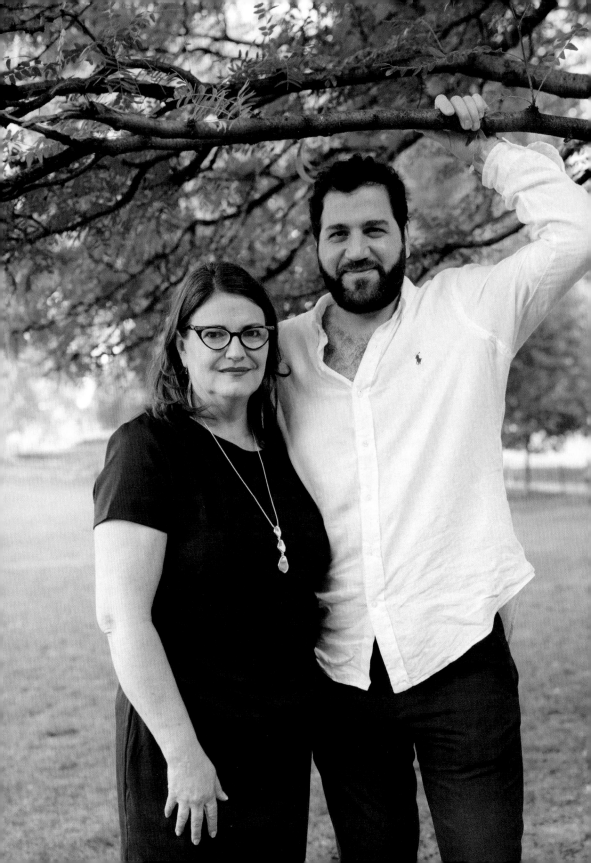

Mustafa Kaymak

———

Valdez, Summer 2005

I went to Safeway looking for shampoo. I was a little lost because I'd never been in an American grocery store, but then I spotted her behind the coffee counter. She had spiky blond hair with designs shaved into the sides of her head. You know in a play, when all the lights go down, and everything is blocked off except the person in the spotlight onstage? That's what this was like.

I was nineteen and in Alaska as part of a work-study program offered by my university. I wanted to leave my small Kurdish village. I wanted to see the world. Of course, when I arrived in Valdez, I learned it was even smaller than my neighborhood in Ankara, and even more uniform. Everyone wore baseball hats and flannel. I preferred muscle tees and tight jeans.

It was only when the woman behind the counter waved that I realized I had been staring. She smiled and motioned for me to come over. She told me her name was Janette and she wanted to know more about my life. She was so confident, and she sounded like she wasn't just being nice—she was genuinely listening. I came back the next day and said, "You, me, go dinner?"

She shook her head and said, "I'm forty-two years old. I have children your age." I looked at the ground, devastated. She said, "Really, it's fine that you asked me, I'm flattered." I took her hand and kissed it and said, "I won't bother you any longer." Then I went off toward the deli.

Valdez, Summer 2006

I spent the year back in Turkey, living alone with my mother, being told by uncles and aunts to stand up straight and to shave my beard. "Even though you've been to America, never forget you are Kurdish," they told me. I kept thinking about Janette. The way she looked at me. I know it sounds ridiculous, but I went back to Valdez the next year to find her.

I walked into the Safeway coffee shop again and saw her behind the counter, and I thought, There she is. I'd spent all year practicing my English. I said, "Hi, do you remember me? Will you go on a date with me?" She said, "I'm sorry, I'm going to Utah for the summer to go to massage therapy school. Otherwise I'd say yes."

"Where is Utah?" I asked. She told me it was pretty far away. I was disappointed, but the tiniest bit hopeful. She had left open the possibility of one day saying yes.

Valdez, Summer 2007

I was waiting tables at a theater conference when I spotted her across the room. I brought her a glass of champagne and touched her arm and said, "Hi." She smiled and I smiled, but she was a little cold, like maybe she'd rather talk to the other guests than to a waiter. When I went back to the kitchen, a woman came up to me and said, "Are you Mustafa?" She handed me a piece of paper that read, "You didn't ask me this time, but I'm asking you." It had Janette's name and phone number.

I called her the next day and we spent that evening at her apartment sharing stories. She told me about being raised Mormon and marrying her high school sweetheart and settling down in Valdez, the same town where she'd grown up. How she'd raised six children and then realized there were other things she wanted to try and people and places she wanted to learn about. How she had divorced her husband and was excommunicated from the church. How she was now free to explore the world.

Janette and I were never apart after that. We went on hikes and bike rides. We rented movies and made pizza. One day we drove to the river and watched the salmon returning from the ocean. She told me the salmon that were born in the river swim out to the ocean for several years, but somehow, they always find their way back home to the river. A month later, I asked her to marry me.

Valdez, Winter 2008

We eloped at the courthouse and for the first time, when winter came, I stayed. Valdez was consumed by darkness. There were no more tourists. There were only locals. They thought our marriage was a fraud, this Muslim man with a Mormon woman twice his age. "This is how terrorists get into the country," someone told Janette. A few weeks later, somebody left a used condom under the windshield wipers of our car. When we went to the police, they just laughed.

Janette had slowly begun attending services again at her Mormon church, and one day she asked me to go with her. As we were leaving, it started to rain, so Janette asked her daughter if she could give us a ride. She said no, her father wouldn't be happy about it. We were soaked and shivering by the time we walked miles back home.

Over the weeks and months of darkness, I started having visions of my home country. The sunlight, the heat. My grandmother's garden. One day I could have sworn I saw it through the snow-covered trees.

"I don't think we can stay here," I told Janette.

Ankara, Summer 2010

I invited Janette to my cousin's wedding, but I was worried about her meeting my family. My fears were relieved once we arrived, and my grandmother, who is blind, said she liked the sound of Janette's footsteps. "Janette," she said, "sounds like the Turkish word for *paradise*."

At the wedding, there was traditional Turkish dancing, where the men and women dance separately and each group holds hands with just their pinkies. It creates this huge chain of people. Janette told me she wanted to join. When she went over, they made room for her. She just blended right in.

The next morning, we sat on my family's balcony overlooking the village. There were children with stacks of *simit* on their heads, yelling, "Anybody wants to buy?" I showed Janette how to put money in a basket, lower it to the street level, and pull up pastries. "It's like something out of a picture book," she said. Wicker baskets floated up and down all around us. Up until Janette's visit, I'd never thought of this ritual as anything but ordinary.

We ate our *simit* on the balcony as the sun settled into the sky. I knew we wouldn't stay here. We'd go back to America and move somewhere entirely new. But there would always be a place for us in Ankara, whenever we found our way back.

Interview by Emma Starer Gross | Photographs by Valerie Chiang

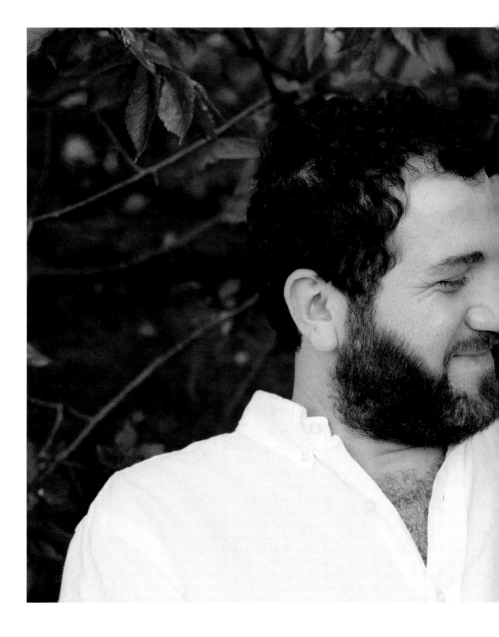

Ai Cheng Goh

————

After my husband and I separated in 1989, I was always worried about money. I hadn't worked in ten years, and so I used credit cards to pay off other credit cards and racked up huge amounts of debt. I found a job at a Chinese restaurant. I'd put myself through college waitressing when I first got to the U.S. at nineteen, and I couldn't believe I had to go back to it. Then one of my customers recruited me to work for a real estate company, and eventually I got a job in marketing for a wellness company. I was working all these jobs and I was so stressed out that at one point my voice became hoarse and I stopped speaking for a while.

By 1996, I was finally able to pay off some of my credit card bills. But I had spent so many years working nonstop that I felt like I had been neglecting my kids, Bobo and Little Tze. I wanted to be able to take them on a real vacation, and not just a work trip with me. I didn't have much time to read or watch TV, but I always kept a stack of *Boston Globe*s in the car, and I'd flip through the travel section when I picked Bobo and Little Tze up from school. One day, I read about a vacation expo being held fifteen minutes away, in Quincy, Massachusetts. I decided it might be fun if we all went together.

On a snowy Saturday in February, I woke my kids up early and we piled into my beat-up Volvo 850. It was a miserable day. The wind was blowing so hard that we almost couldn't see the road ahead of us on I-93 North. The snow fell harder, which was very scary, but we were so close—only one or two exits away—and I didn't want to turn back. When we got to the expo center, there were hardly any other cars in the parking lot. The weather was so bad that no one else had bothered to show up. Inside, there were rows and rows of booths, but all the vendors looked bored and annoyed.

That didn't make a difference to us. We were actually kind of excited that no one else was there. We went around the booths and gathered all the travel brochures. Then my daughter noticed there were raffles you could enter to win a free vacation. I said, "Let's go over and put our names into every single one." I gave Little Tze some of my business cards and we walked down the aisles dropping them into the raffle bowls. We went home satisfied, our arms full of brochures.

A few months later, we started getting letters in the mail about vacations we'd won. First we found out we had won a time-share a couple hours away, but it turned out that you had to pay a lot of money for it. It didn't seem worth it. We also won a ski trip, but what was the point if they didn't give you equipment rentals? Then a letter arrived informing us that we had won a cruise to Alaska. I was like, What's a cruise? I didn't even know. Then I began to read further and understand that it was like a hotel on a ship, and I thought, What an opportunity! It was a big deal. How could we not go?

I'd only ever been on a ship once before. My parents were extremely poor, and when I was a baby in Singapore, they sold me to a couple who thought they couldn't have children. But after the couple adopted me, the woman found out she was pregnant, and they sold me to someone else. This happened a few times. When I was five, I was sold to a woman at a brothel. The madams there adopted castaways like me. We called the madams "sisters." This sister took care of me for several years, before she found a rich husband in Malaysia. Then I was given to another sister, who took me with her on a boat to Hong Kong because she'd found a husband there. I was twelve, the age a lot of girls start working at the brothels, but I was lucky to escape before the sisters ever put me to work.

More than thirty years later, Bobo, Little Tze, and I boarded this gigantic cruise ship at the port in Seattle. It was a sunny day in July, and I had a nervous, excited feeling, the kind you get when you don't know what to expect. I thought our family would hang out together, just the three of us, like we did at home. And at first we did. We went in the hot tub; we played backgammon, foosball, and pinball.

But one day, something happened that I did not expect: Bobo told me he made a new friend, Sal, and that he was going to his cabin to play Magic: The Gathering. Little Tze wanted to go, too, and I said okay because I thought they would only be gone for an hour. But they were gone the whole day. They came back for dinner, and immediately afterward, they wanted to go play again. Of course I let them go. I trusted Bobo, and I think it meant a lot to him, to be able to go do his own thing, even if his little sister came along.

When they came back to the room that night, they told me Sal had the most luxurious suite. "It's like a house!" Bobo said. It had a living room, dining room, and automated window shades that lifted up to reveal a panoramic view of the ocean. Not like our tiny window overlooking the deck. I was quite sad—not the bad kind of sad, but that feeling in your heart that hurts because you see that your kids are growing up and starting to lead their own lives. It would have happened sooner or later, but in that moment on the cruise ship, it came as a shock. I could see, for the first time, that they didn't need me as much anymore.

The next few days went by slowly. Bobo and Little Tze were gone most of the time, so I was on my own. To pass the time, I liked to stand on the deck of the ship and listen to the sound of the icebergs cracking. Huge chunks of ice sliding into the ocean, like an entire mountain breaking apart. You know the sound of Coca-Cola when you pour it into a glass of ice, that crackling? That's what it sounds like, the boom boom boom of ice falling down in slow motion. I loved that sound, and when I heard it, I felt peace and acceptance in my heart.

Interview by Natalie So | Photographs by Kayla Reefer

Anna Patterson

———

Bavaria, where I grew up, is right across the border from Austria. You ever see *The Sound of Music*? It's mountains. So when I came to Montana in 1961, I was so happy to see the mountains. And the people here, they were so nice to me. My neighbors drove me to and from church. They asked if I wanted to sing in the choir. They invited me to their houses. I thought, This is it, I'm going to stay here.

I found a job as a waitress and I made good tips. I met Bill at the café, and that's when my good life started. He was so kind. He worked as a railroad engineer. And you know what I noticed? He was always clean. The others came in coveralls and he always wore a white shirt.

It wasn't this big, great love at first, but it grew into it because he was such a good, gentle man. He listened to me when I talked, and when he found out that I'd left my two children behind to come to the United States, he promised to pay for me to get my little ones from my mother in Germany and bring them to Montana. That was the first time in my life that I knew I was loved.

In Germany, I was treated like the lowest of the low because I had children from two different American soldiers. The first was going to marry me, but when he got drunk one time, he tried to hit me. So that was it, I left him. My second son was from a man that I really loved. But when I told him about the baby, he left. The hospital where I gave birth to my second son put me in a maternity ward with prostitutes. I nursed the baby and he threw up what he ate, and they never fed him anything else. They never cleaned him up. Nothing. All I wanted to do was to come to America and have a better life for my children.

Bill and I had a son of our own, Jim, when I was twenty-nine. Bill was very generous, and I stayed at home with the children for ten years. But after a while, I wanted some extra money to buy things for them. I would buy them Nikes—whatever the other kids had. And you know how it is when you have your own money in your pocket. I found out there was a shop in Livingston, Dan Bailey's, where they made flies for fly-fishing. The flies are made of floss, hooks, and other materials like feathers and animal hair, and they're made to resemble insects to attract trout.

Fly-fishing is very big in Livingston. They have the Fly Fishers International in an old schoolhouse. They have tournaments for the kids, and fishermen from all over the country come here to fish on the Yellowstone River. And Dan Bailey was very famous. He opened his shop in the 1940s, and added a mail-order business. At one point he sold the most flies of any company in the U.S.

So, I took a simple test and got a job tying flies. I'd take Jim to school in the morning, then go to work at the fly shop. You got paid by the piece, and you could do them from home or at the shop, as long as you tied six dozen flies a day.

I tied all the Wulff flies: the Grey Wulff, the White Wulff, the Grizzly Wulff. They used peacock feathers, ostrich feathers, white calf tail, and special hackle, which comes from chickens. They sold for $1.50, and they were designed to sit on top of the water.

I think I took to fly-tying partly because my mother was a professional seamstress. She taught me to sew everything by hand from the age of six. Then in school in Germany, we learned crocheting and knitting. I had about ten or twelve grand-champion ribbons for my knitting.

I was very, very particular with these flies. I measured everything. I measured the tail. I measured the body. I measured the wings. I measured the hackle—until one day my supervisor came by my seat and dropped a note on my desk and walked away. I looked at the note, and it said, "Less quality, more quantity." My supervisor said, "I want my flies, but you know, the fish don't care what they look like." So I relaxed more and I picked up speed.

I'd put on headphones and listen to big band music—Frank Sinatra, Mario Lanza, Dean Martin—and it was like I was in a different world for a few hours. And then Jim would come and pick me up, and I'd go home to my daily routine. That was a really happy time.

In 1994, a friend of mine came to the shop and asked if I would tie a fly that he invented. He called it Wright's Royal, and it used peacock herl, red floss, and light elk hair. He loved it and asked for two dozen. About a month after that, somebody from the office said I got a letter from the Supreme Court in Washington, D.C. I thought he was kidding. But it said, "Dear Mrs. Patterson. Thank you so much. I tried the fly." It was from Sandra Day O'Connor. To this day, I still don't know how she got ahold of the fly, but she said she loved it and caught a lot of fish with it.

Bill died from a blood disease when I was in my early sixties. I could have married again, but I didn't want to, because I could have never found anybody like him. He was the best thing that ever happened in my life, and I thank God every day that he took good care of my children and me. I always say he's still taking care of me, because I get a pension from the railroad.

Now, I live by myself, but my middle son lives right here in Livingston. Before he retired, he was a railroad engineer, like Bill. My oldest son lives in Idaho and he works for the Coulee Dam in Washington.

When I was eighty-one, my youngest son, Jim, had a baby. They named her Anastasia, and they call her Annie. Jim and his wife, they could not raise this baby. So I had her until she was fourteen months old, and then Heidi, her aunt on her mother's side, adopted her.

I spent so many years dealing with Jim's schizophrenia. He is doing wonderfully now, he is the best son you could ask for. But for years, I tried to help him. He was homeless so many times. I spent so much money on furniture, pots, pans, and then he would move and leave it all behind and we'd start again. It wasn't his fault. I don't blame anybody. But I got so deep in debt, I couldn't dig myself out. I had to sell my house and move into the apartment I live in now.

I'm so grateful that I get to experience this little girl, Annie. It's like a miracle. I want to teach her to sing, "You are my sunshine. You are my sunshine." I won't be here to see her grow up. But I want her to be loved.

Interview by Jessica P. Ogilvie | *Photographs by Nicholas Albrecht*

acknowledgments

This book, a companion to the Apple TV+ series of the same name, would not have been possible without the show's executive producers: Lee Eisenberg, Joshuah Bearman, Emily V. Gordon, Sian Heder, Kumail Nanjiani, Arthur Spector, Alan Yang, and Joshua Davis. Thank you to Natalie Sandy at Quantity Entertainment, Dan Shear at Universal Television, David McCormick at McCormick Lit, Sean McDonald at MCD/Farrar, Straus and Giroux, and David Klawans, Dan Fierman, Melis Tusiray, Mackenzie Fargo, and James Austen at *Epic Magazine*.

An additional note of gratitude to the writers who brought out the best in the people they interviewed. They include: Charlie Alderman, Julia Black, Alexa Daugherty, Ann Derrick-Gaillot, Lara Edwards, Sasha Geffen, Emma Starer Gross, Saira Khan, Gina Mei, Anh Nguyen, Jessica P. Ogilvie, Jen Percy, Natalie So, Harry Spitzer, and Jennifer Swann, who also assigned and edited. Thank you to the photographers who traveled the country to capture the portraits in these pages: Nicholas Albrecht, Mel Brunelle, Valerie Chiang, Enkrypt Los Angeles, Kathryn Harrison, Mark Hartman, Nailah Howze, Oriana Koren, Ricardo Nagaoka, Kayla Reefer, William Widmer, and Katra Ziyad. Last but not least, thank you to Will Staehle, who designed the book, and to Emily Berkey, who directed the photography.

Of course, no iteration of *Little America* would exist were it not for the generous participation, time, and trust of everyone who shared their stories with *Epic Magazine*'s writers and researchers. Our gratitude extends to those whose names and stories did not make it into this book, as well as to friends, spouses, and family members of the people featured in these pages. Their additional memories helped us craft a fuller, more vibrant portrait of their loved ones, both in this book and on television.

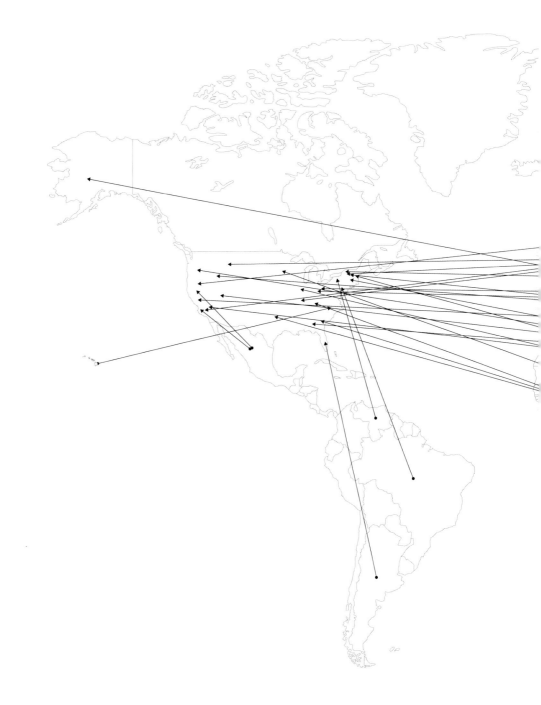

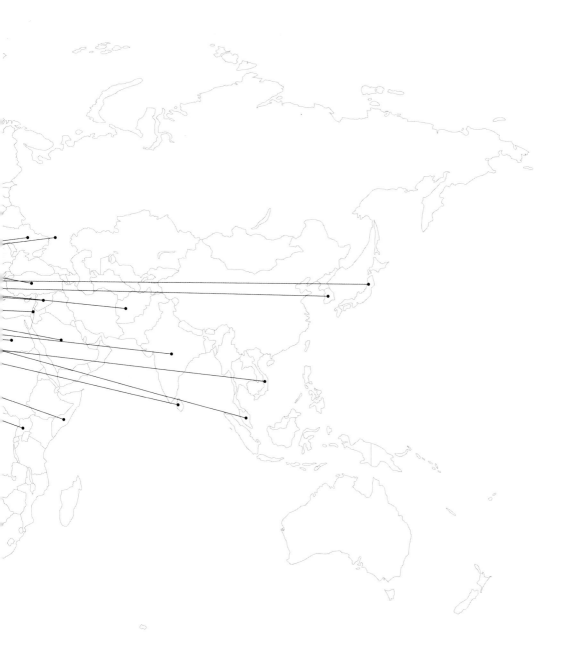